New Expressions

ADULT COLORING BOOKS BASED ON ABSTRACT EXPRESSION

Ken O'Toole

Irish Lion Media

FORT WORTH, TEXAS

Copyright © 2017 by Ken O'Toole.

All rights reserved. No part of this publication may be reproduced, distributed or transmitted in any form or by any means, including photocopying, recording, or other electronic or mechanical methods, without the prior written permission of the publisher, except in the case of brief quotations embodied in critical reviews and certain other noncommercial uses permitted by copyright law. For permission requests, write to the publisher, addressed "Attention: Permissions Coordinator," at the address below.

S.K. O'Toole/Irish Lion Media

6624 Monterrey Dr.

Fort Worth, Texas/76112

www.irishlionmedia.com

Ordering Information:

Quantity sales. Special discounts are available on quantity purchases by corporations, associations, and others. For details, contact the "Special Sales Department" at the address above.

New Expressions: Adult Coloring Books Based on Abstract Expression/ Ken O'Toole. —1st ed.

ISBN-13: 978-1545551929
ISBN-10: 1545551928

Dedicated to All Artists

In the brush doing what it's doing, it will stumble on what one couldn't do by oneself.

- Robert Motherwell -

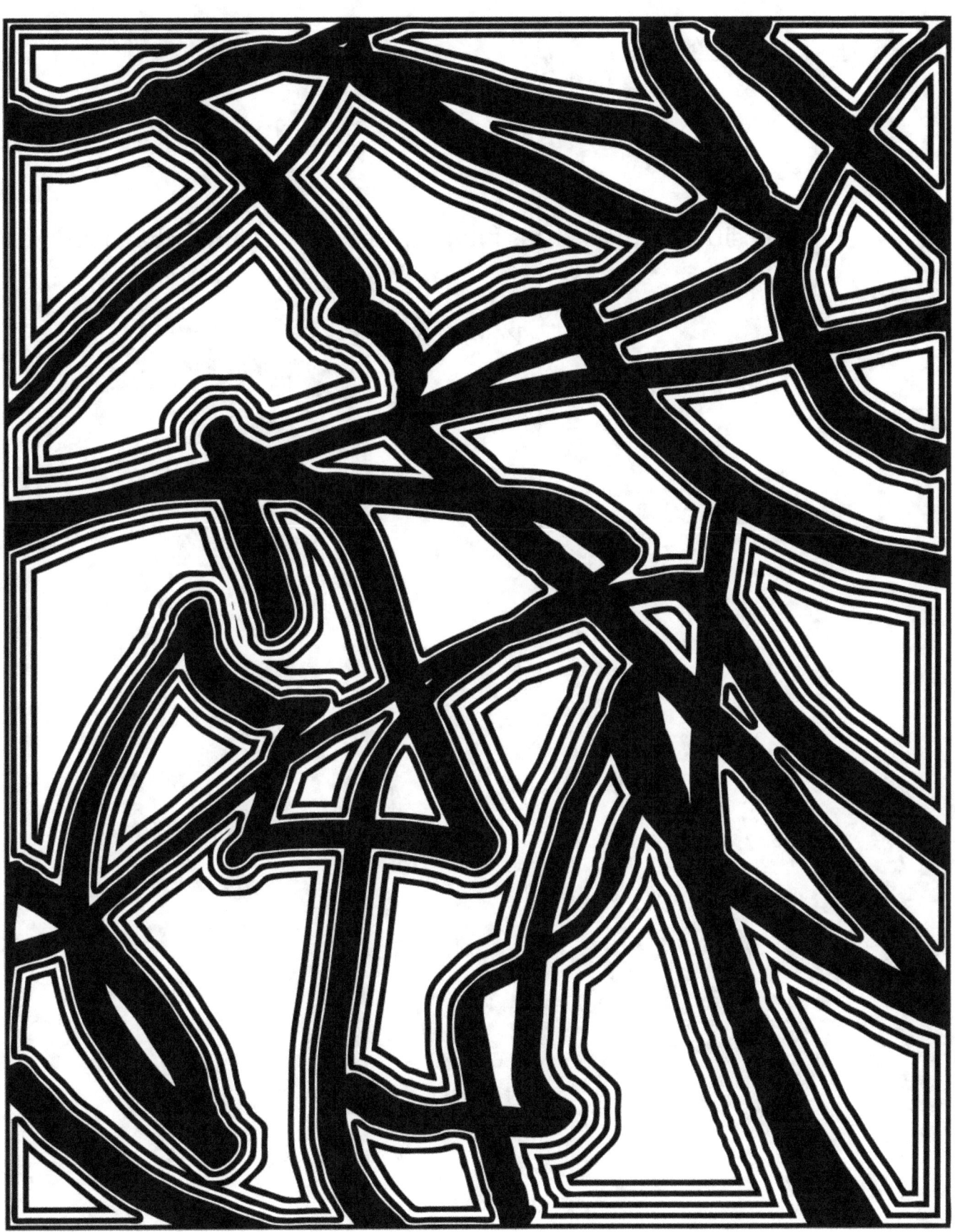

The position of the artist is humble. He is essentially a channel.

- Piet Mondrian -

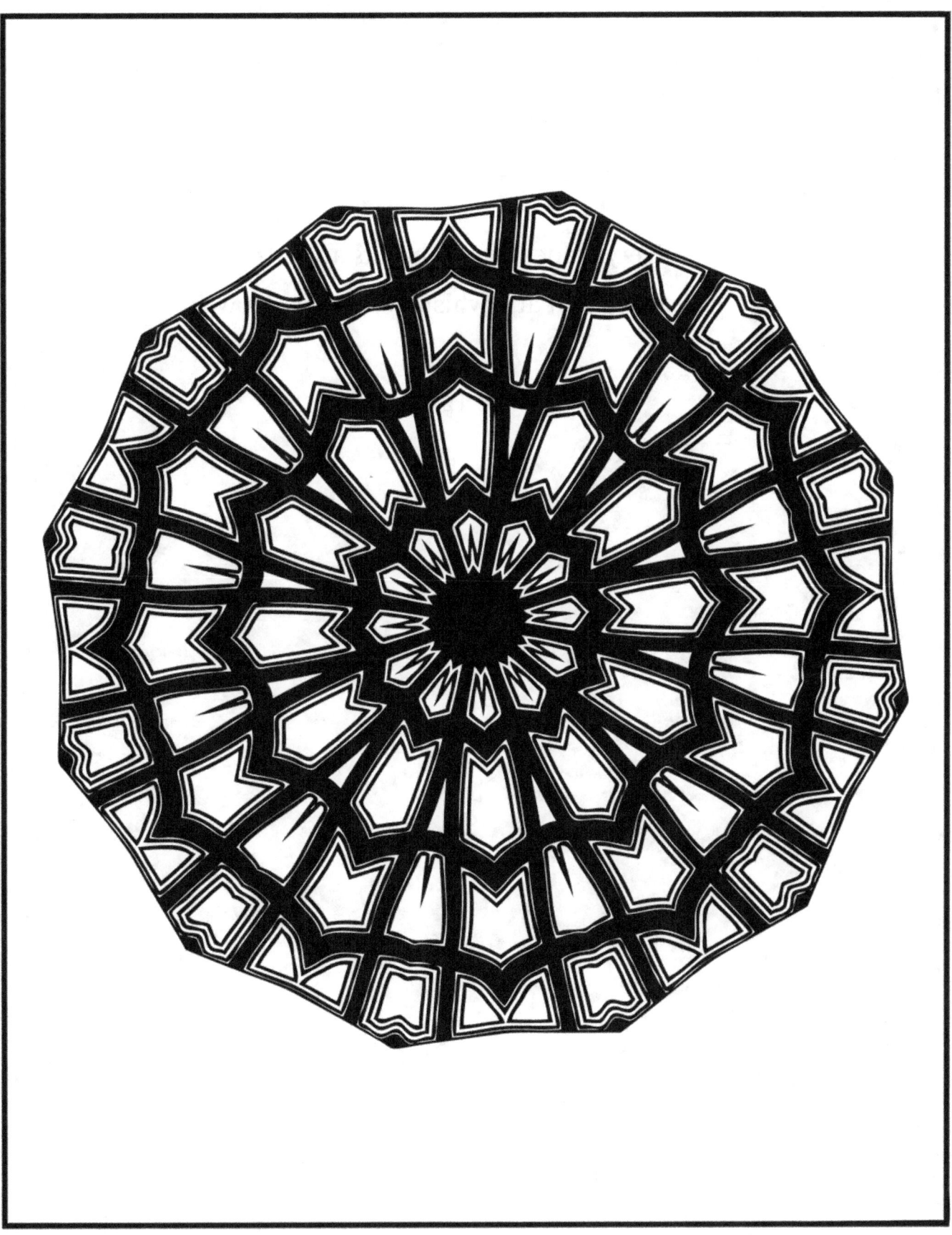

Every blade of grass has its angel that bends over it and whispers, "Grow, grow."

- The Talmud -

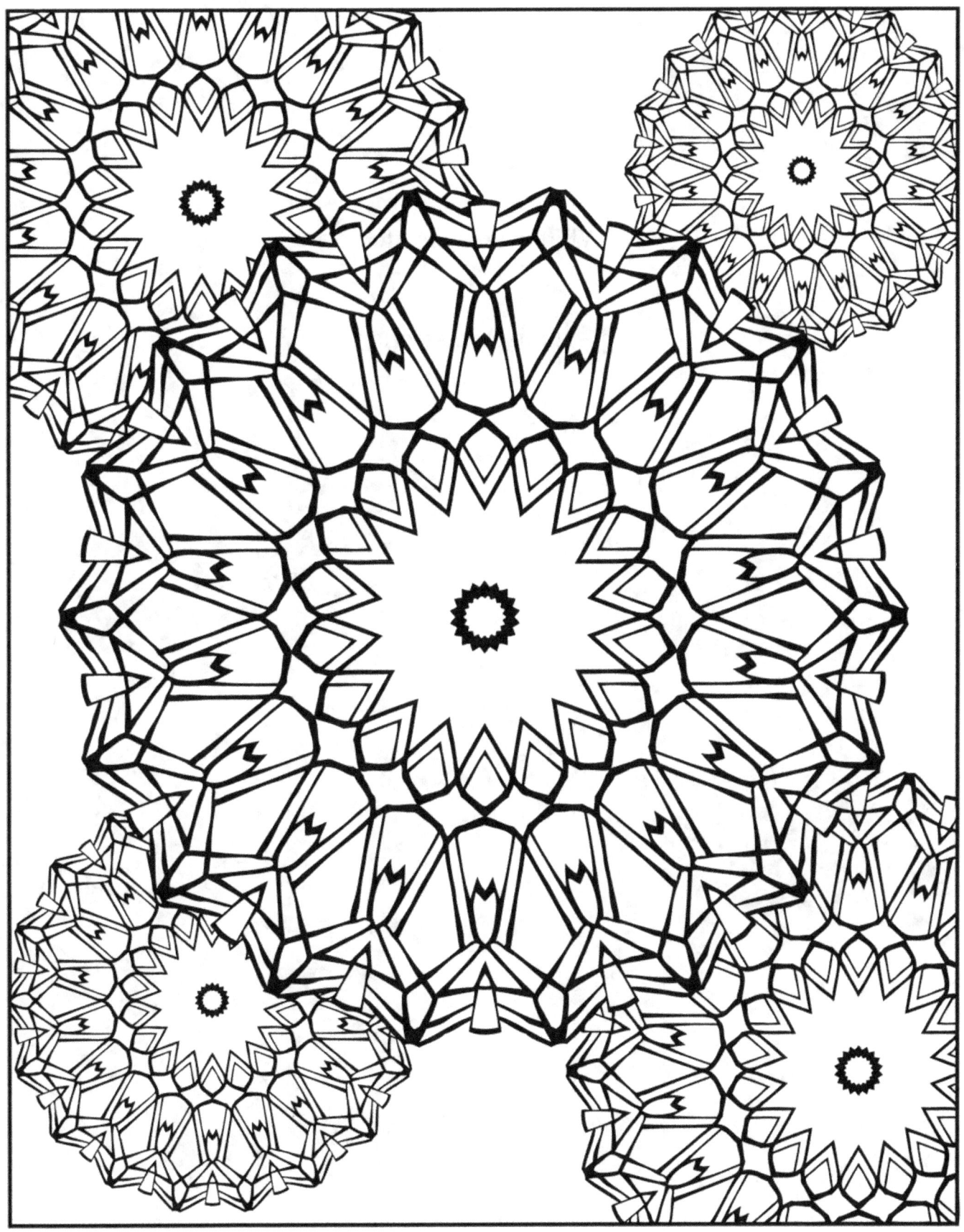

What we play is life.

- Louis Armstrong -

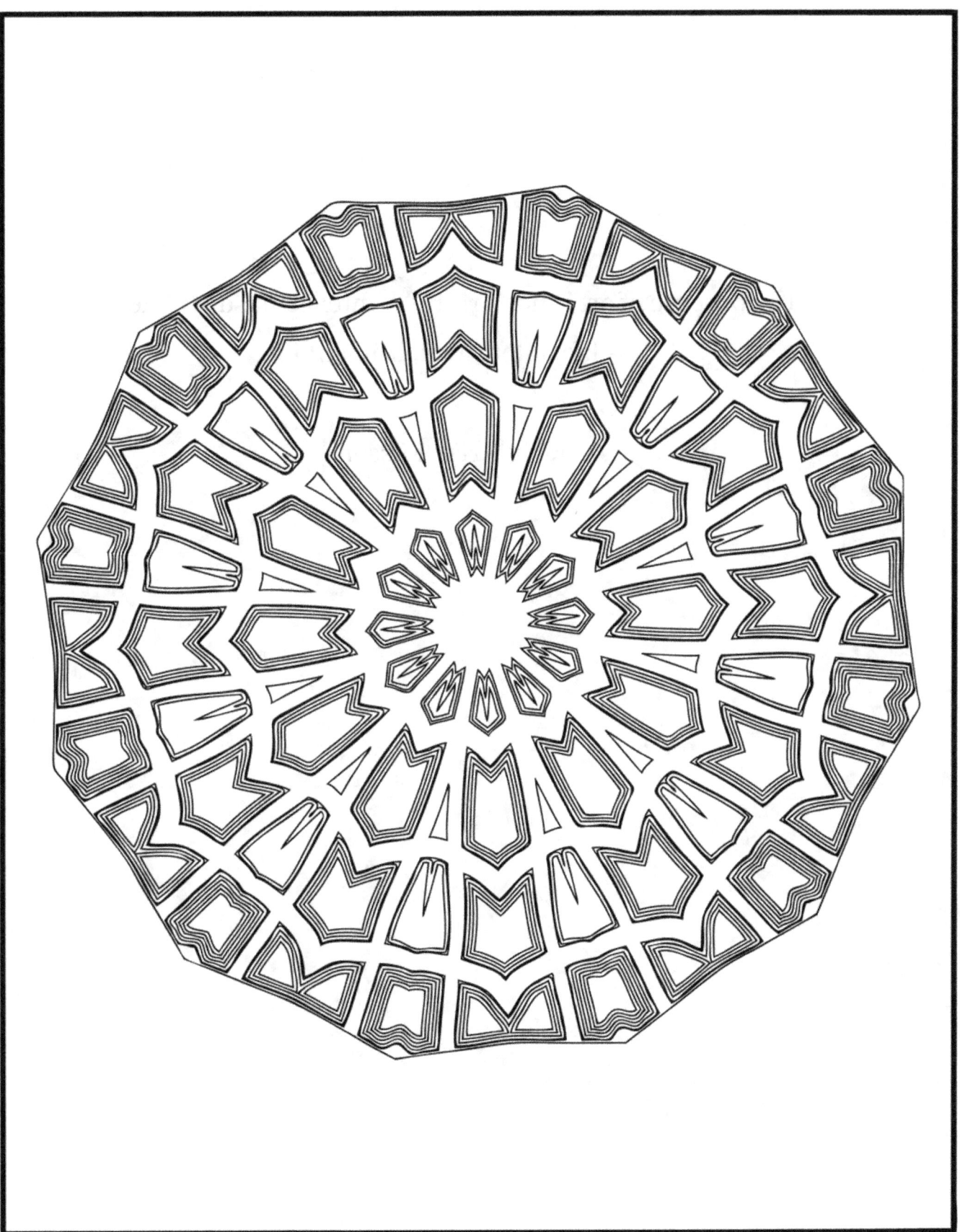

The purpose of art is not a rarified, intellectual distillate –
it is life, intensified, brilliant life.

- Alain Arias-Misson -

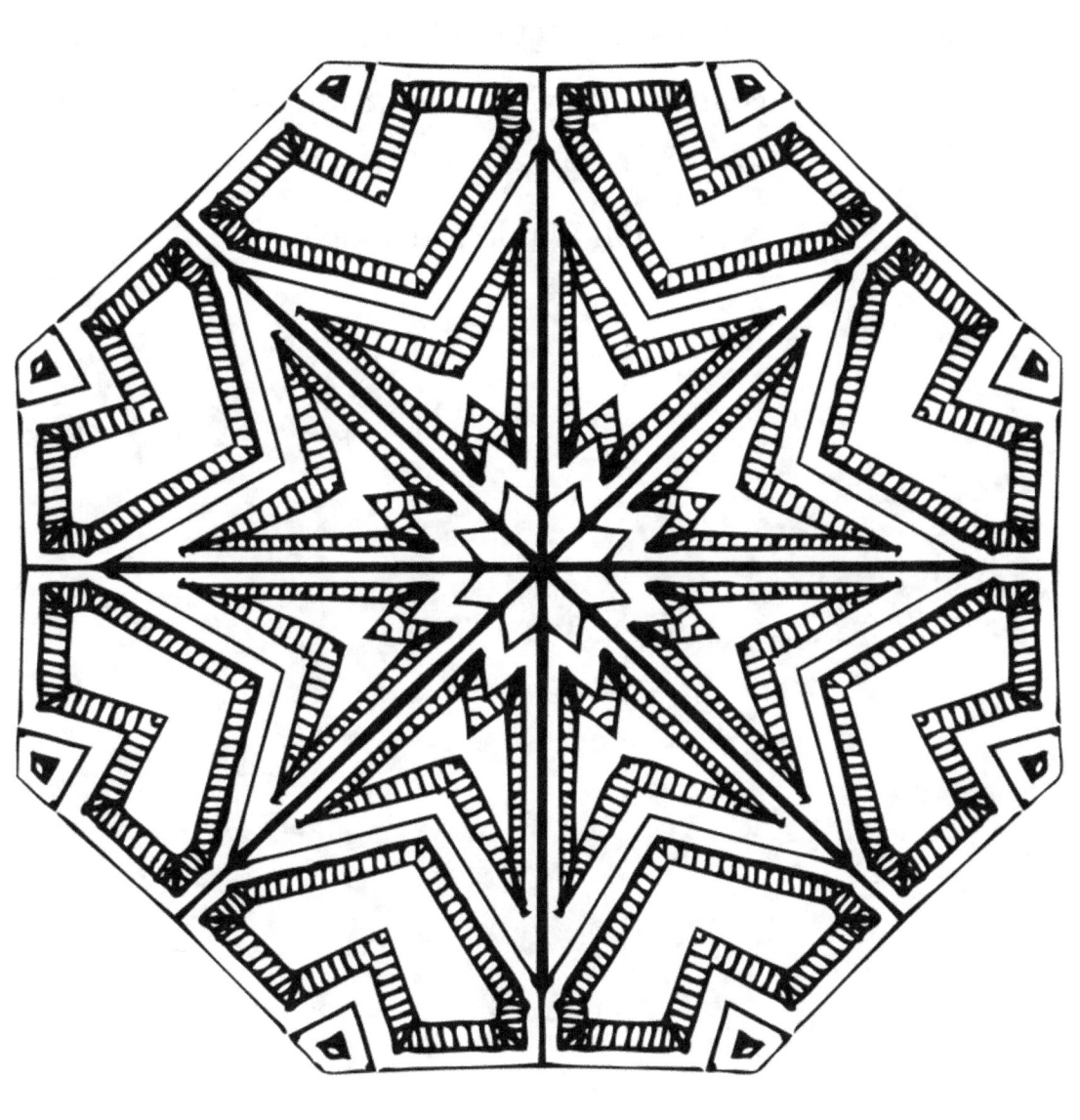

What lies behind us and what lies before us are tiny matters, compared to what lies within us.

- Ralph Waldo Emerson -

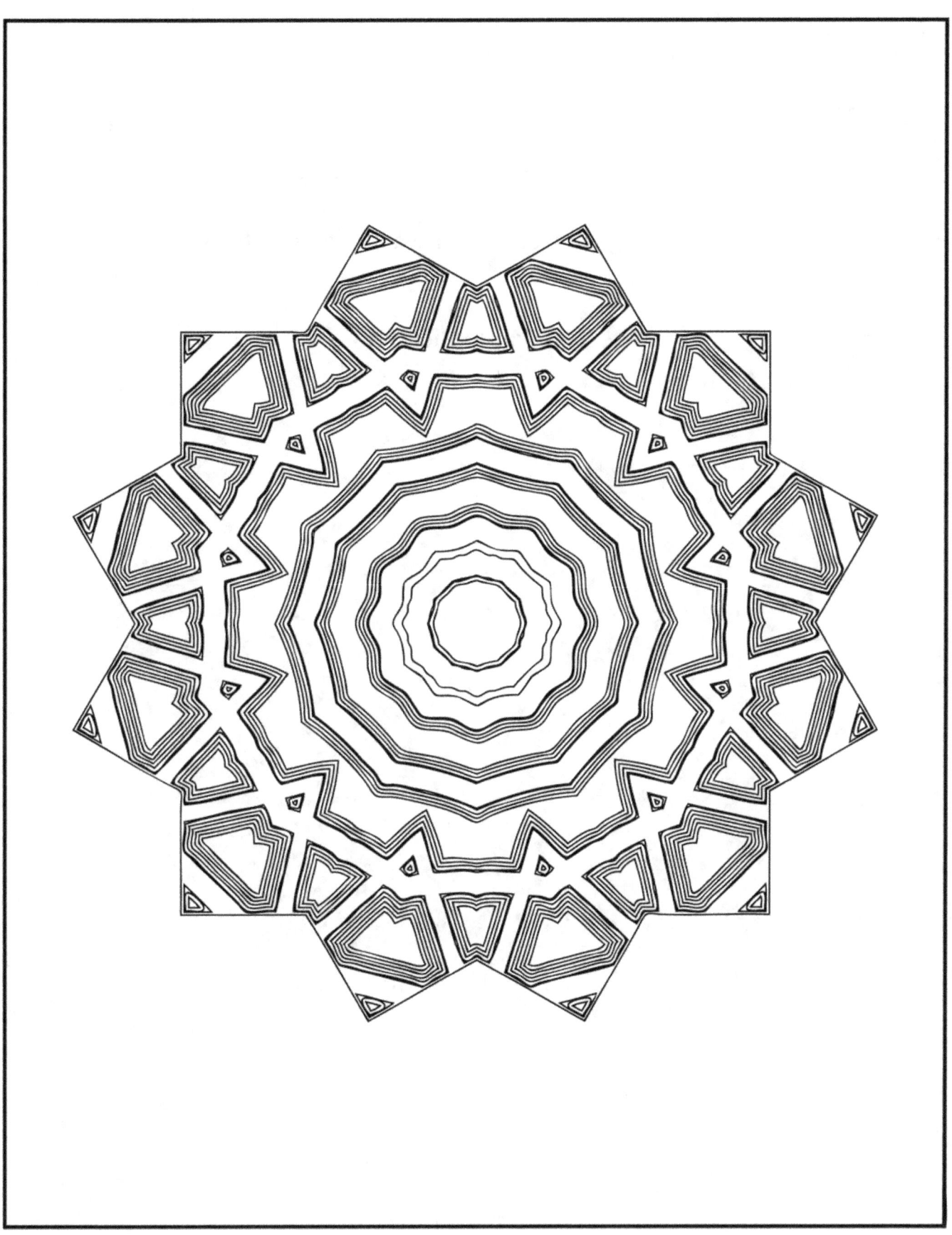

Painting is just another way to keep a diary.

- Pablo Picasso -

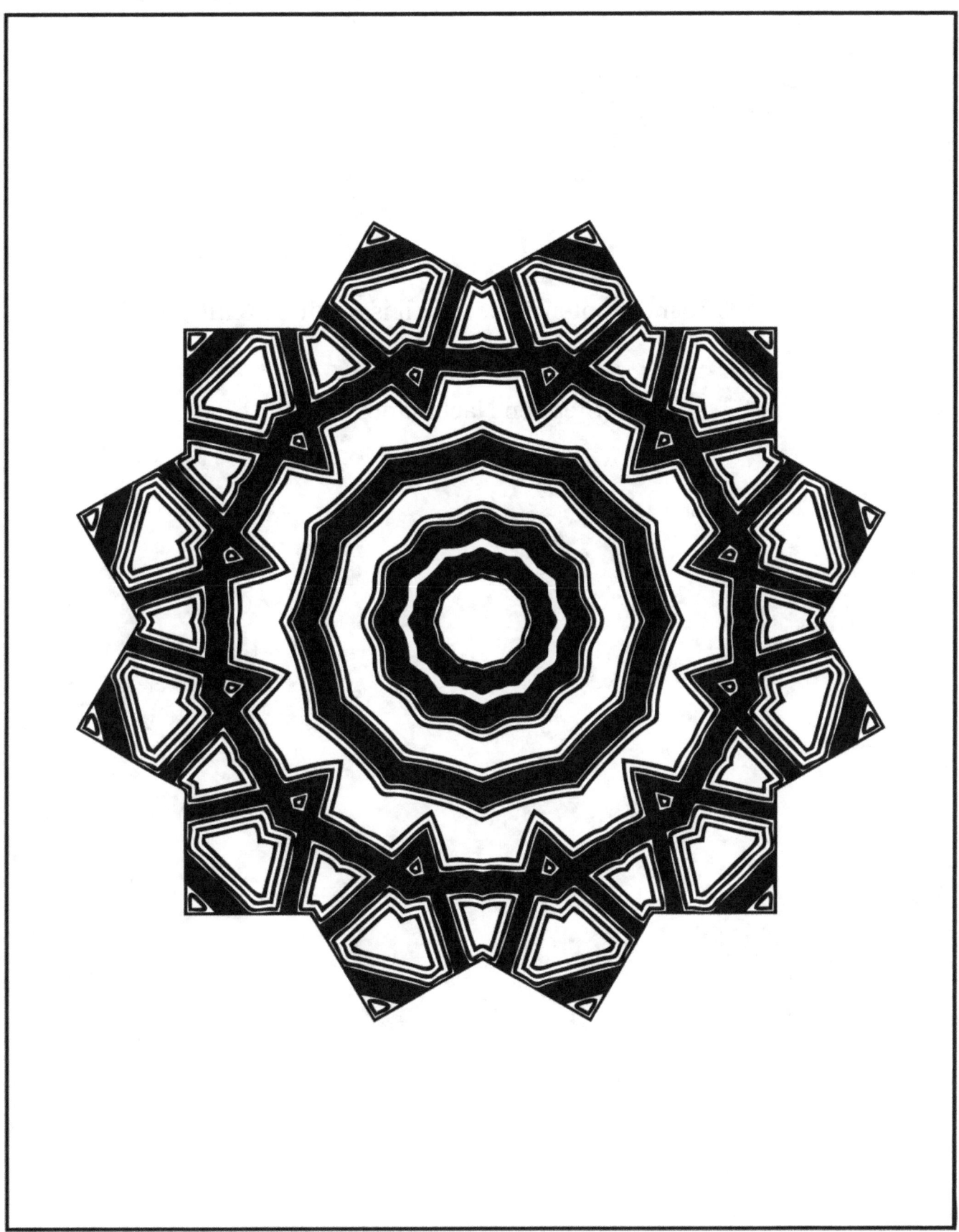

The most potent muse of all is our inner child.

- Stephen Nachmanovitch -

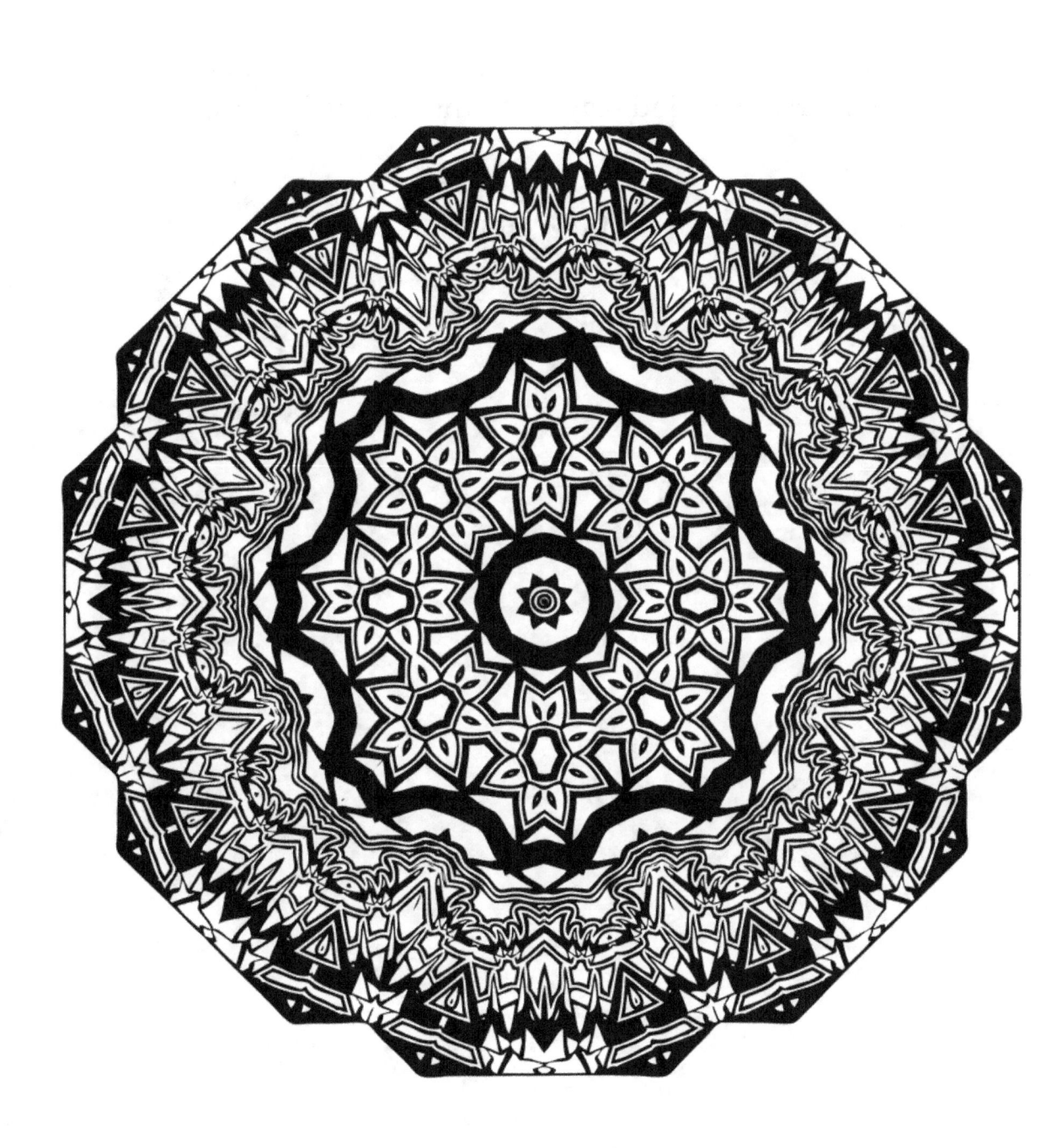

The creative mind plays with the objects it loves.

- C. G. Jung -

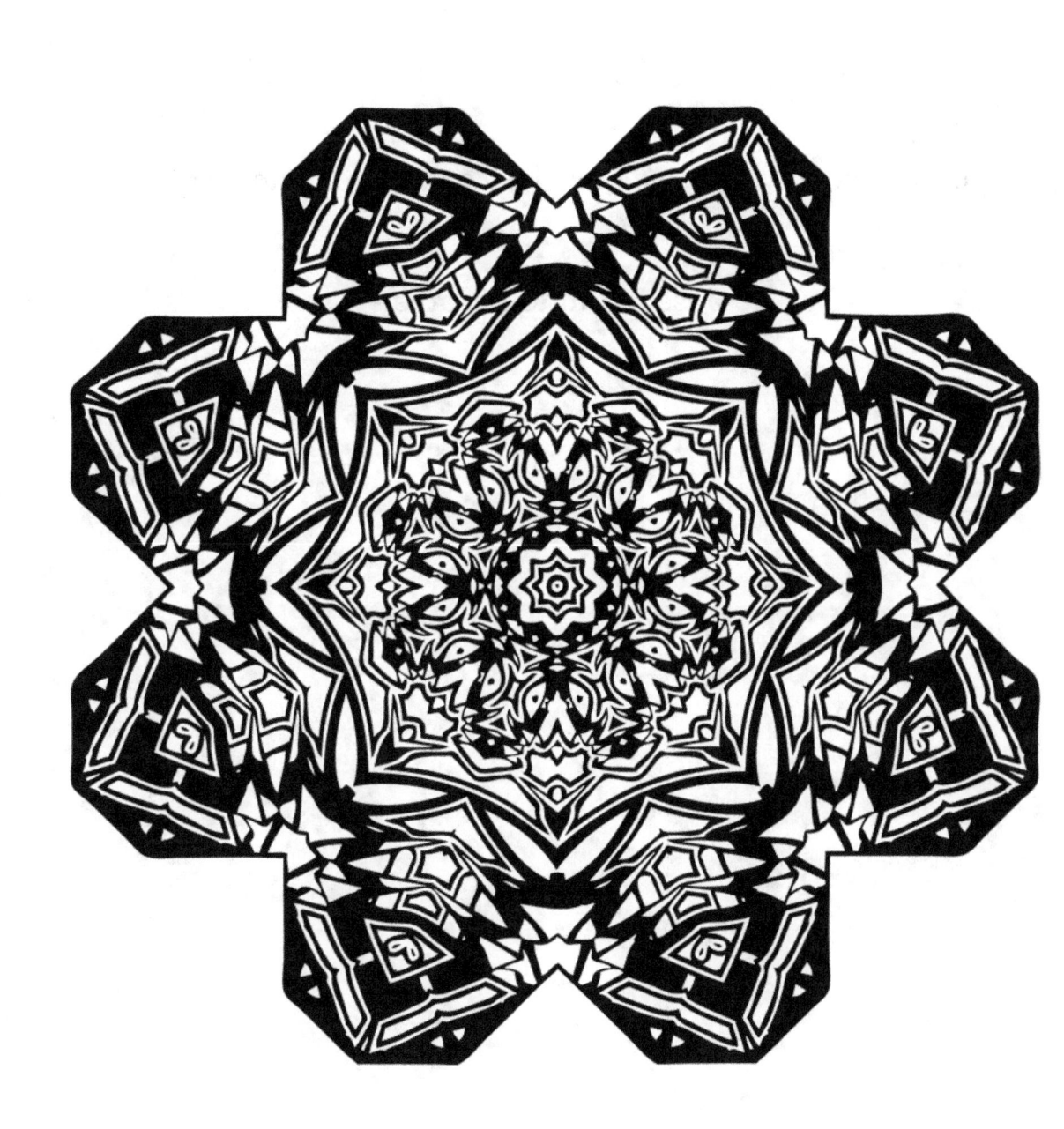

To live a creative life, we must lose our fear of being wrong.

- Joseph Chilton Pearce -

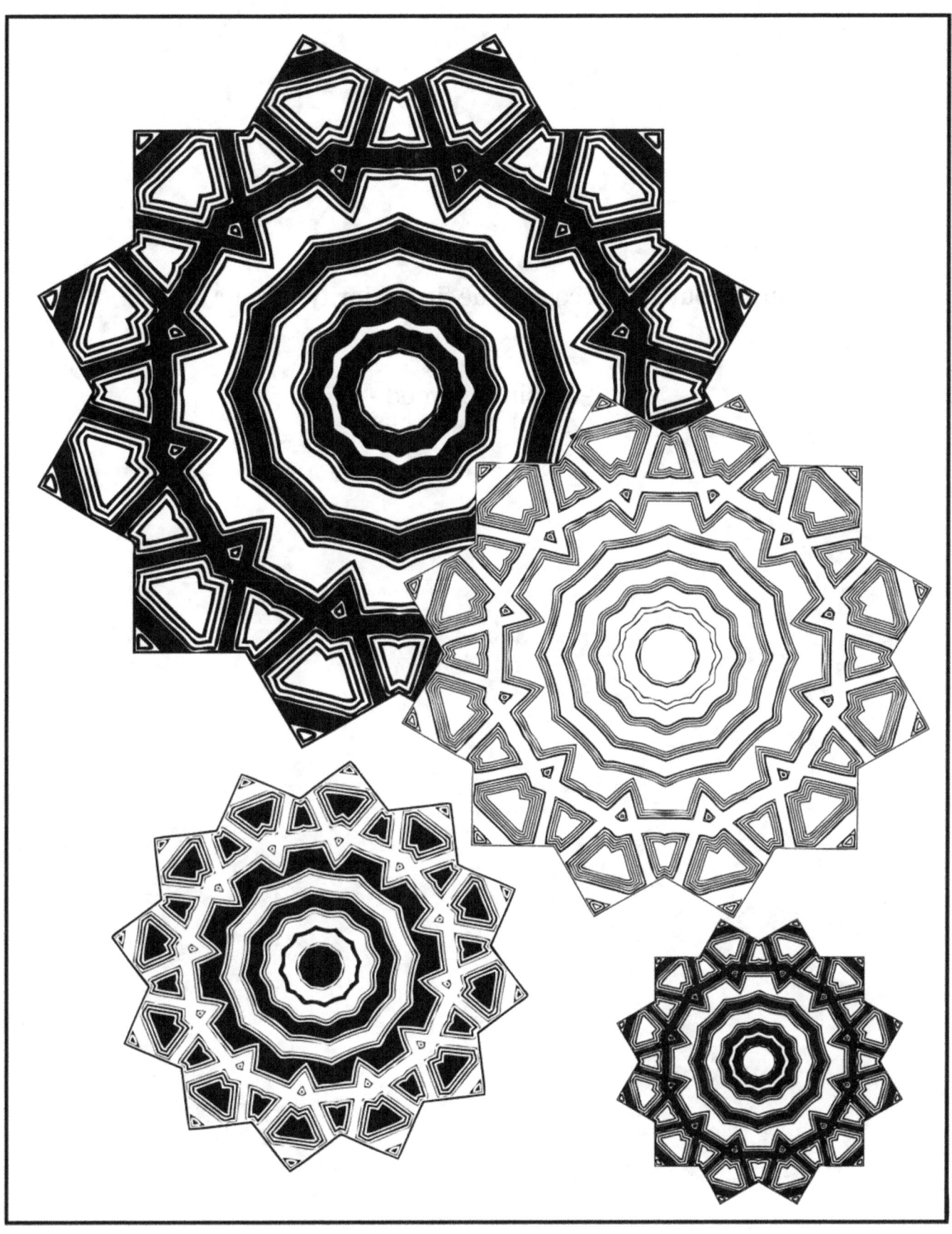

Make your own recovery the first priority in your life.

- Robin Norwood -

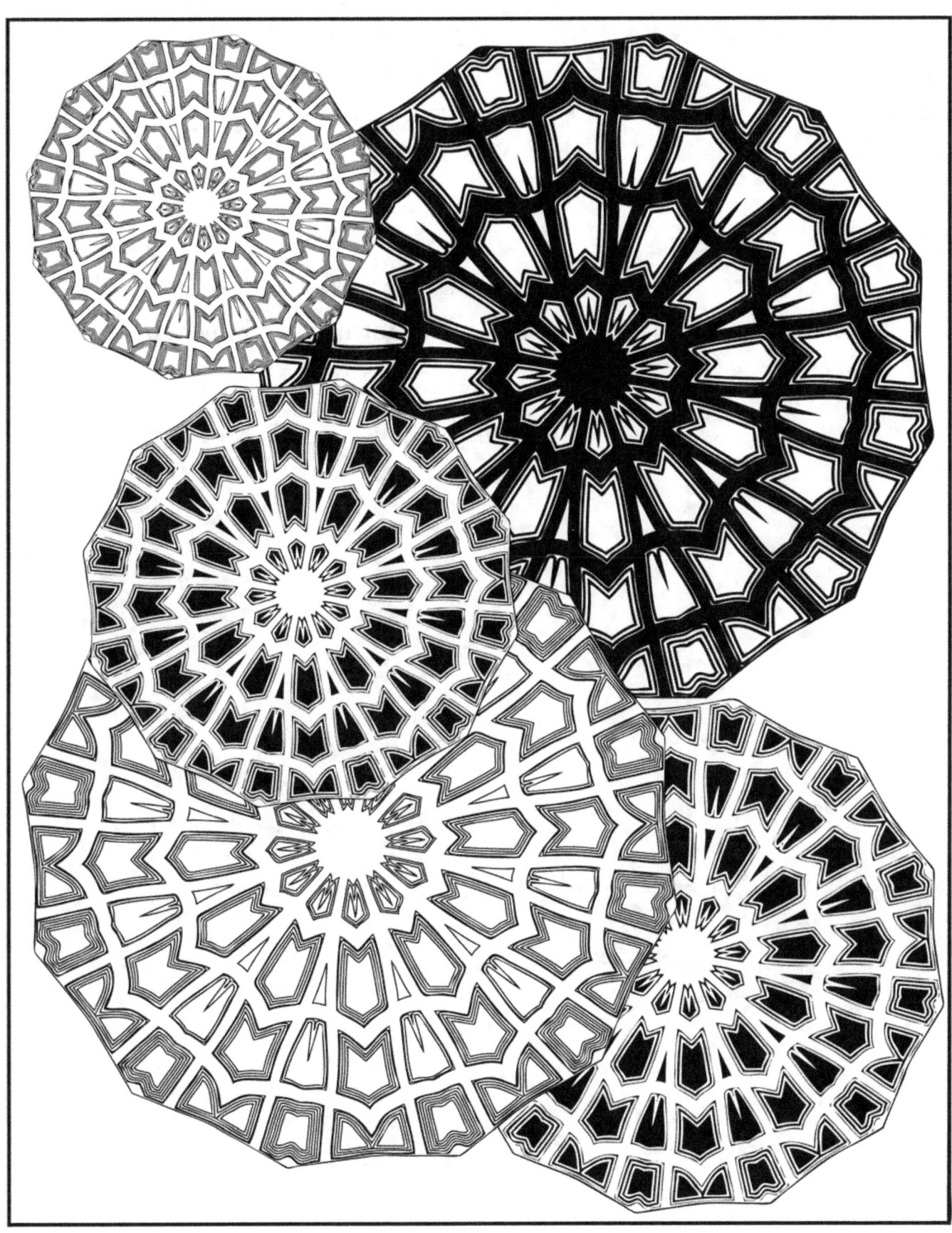

Every time we say, "*Let there be*," in any form, something happens.

- Stella Terrill Mann -

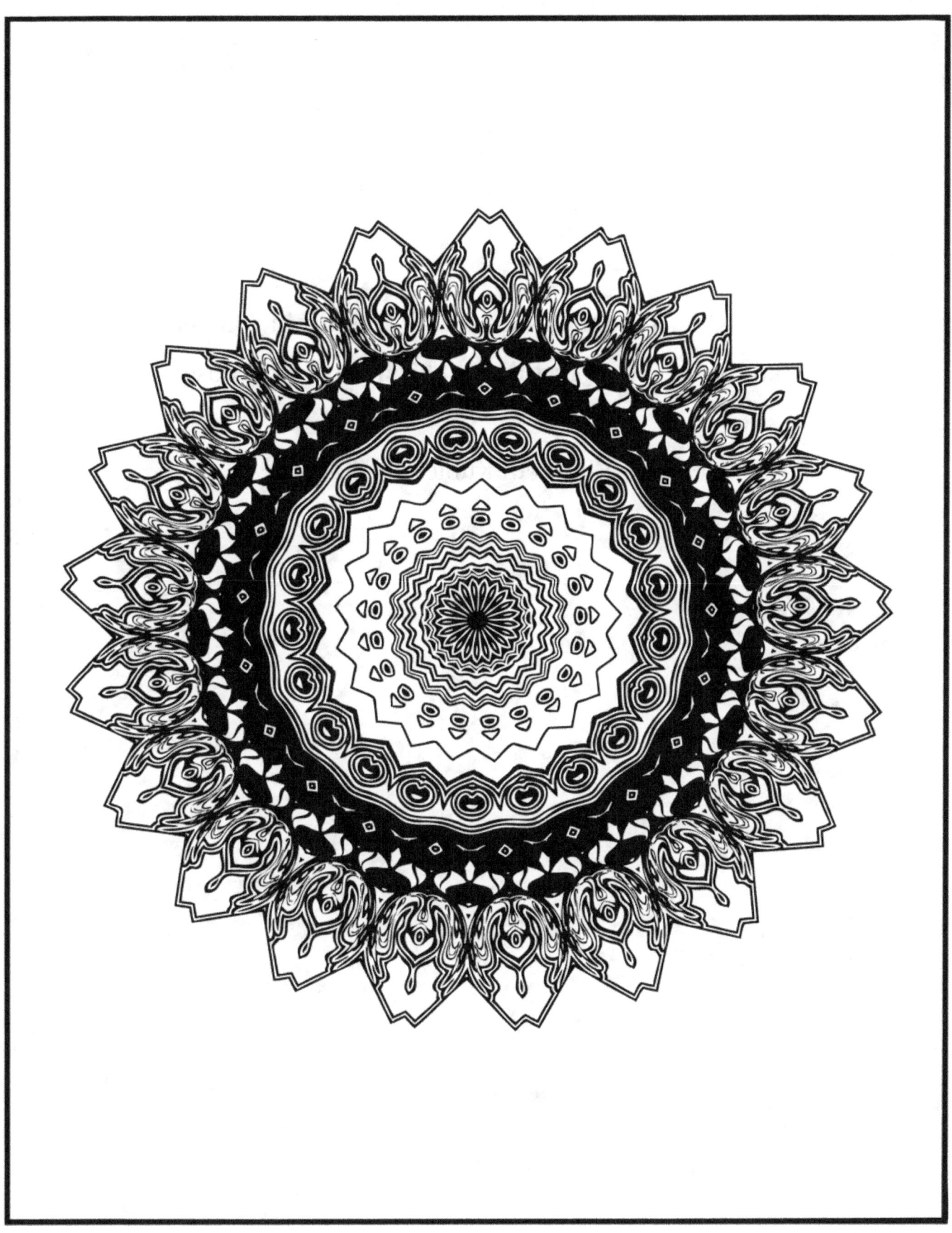

Learn to get in touch with the silence within yourself
and know that everything in this life has a purpose.

- Elisabeth Kübler-Ross -

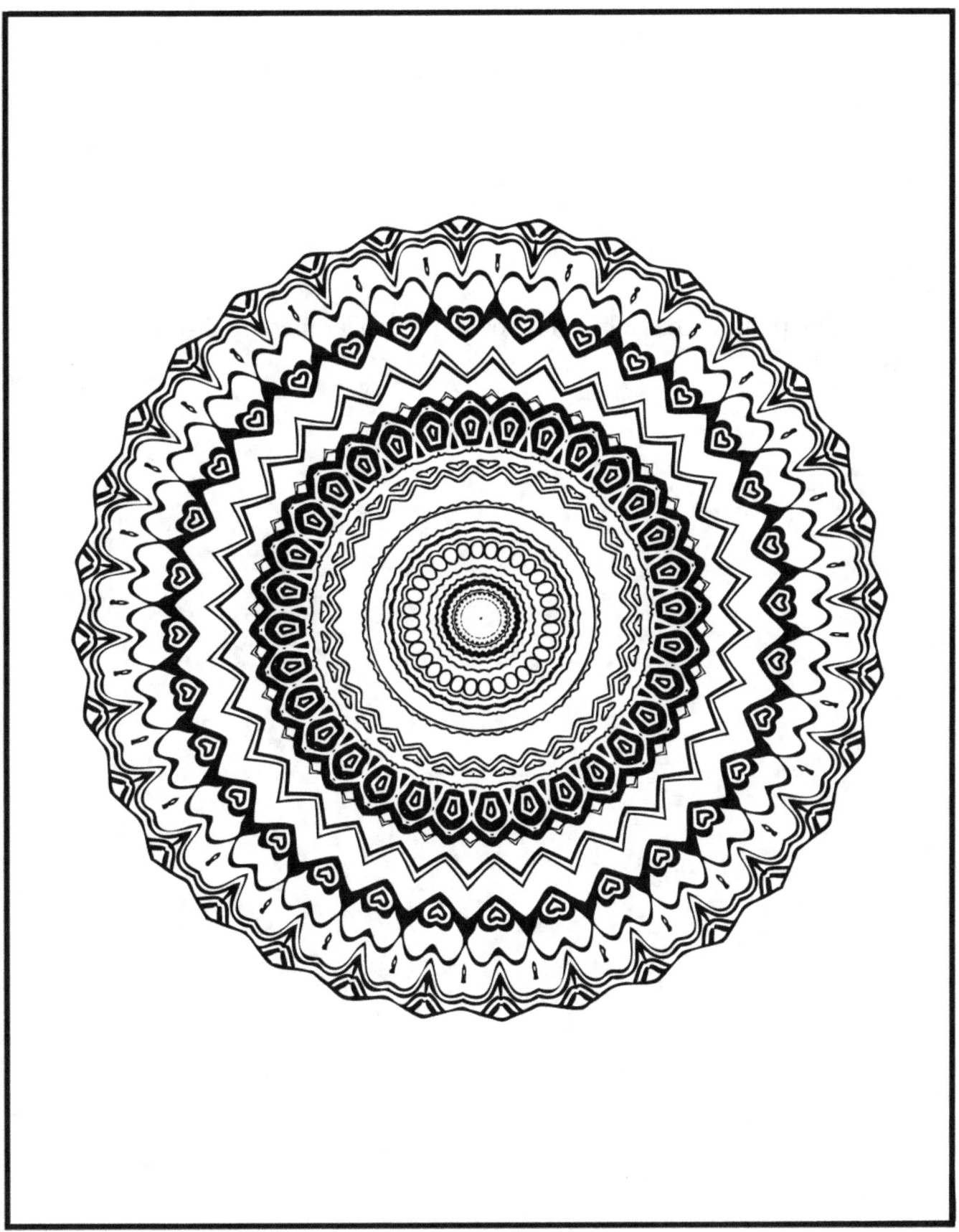

The painting has a life of its own. I try to let it come through.

- Jackson Pollock -

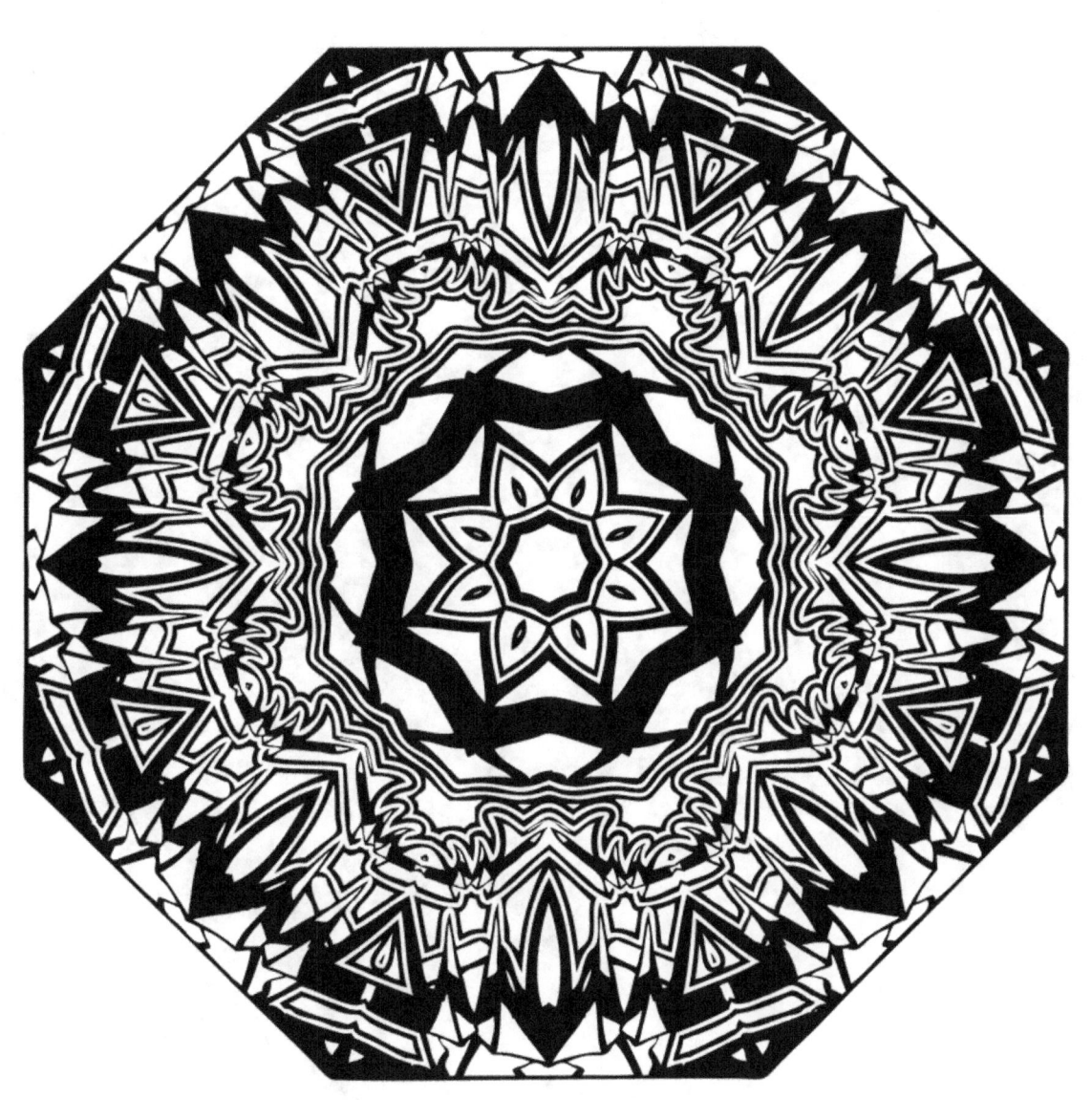

I shut my eyes in order to see.

- Paul Gauguin –

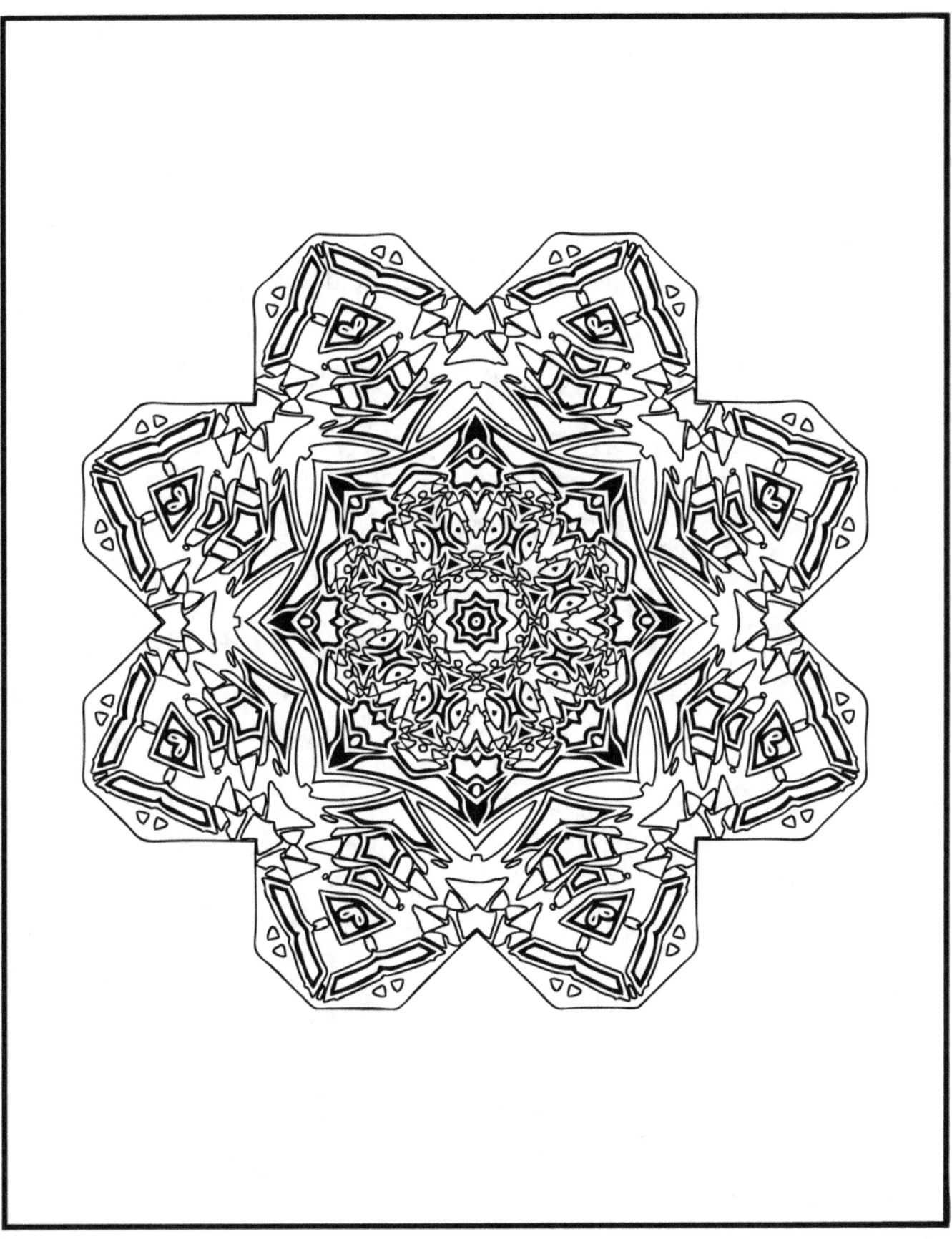

I merely took the energy it takes to pout and wrote some blues.

- Duke Ellington –

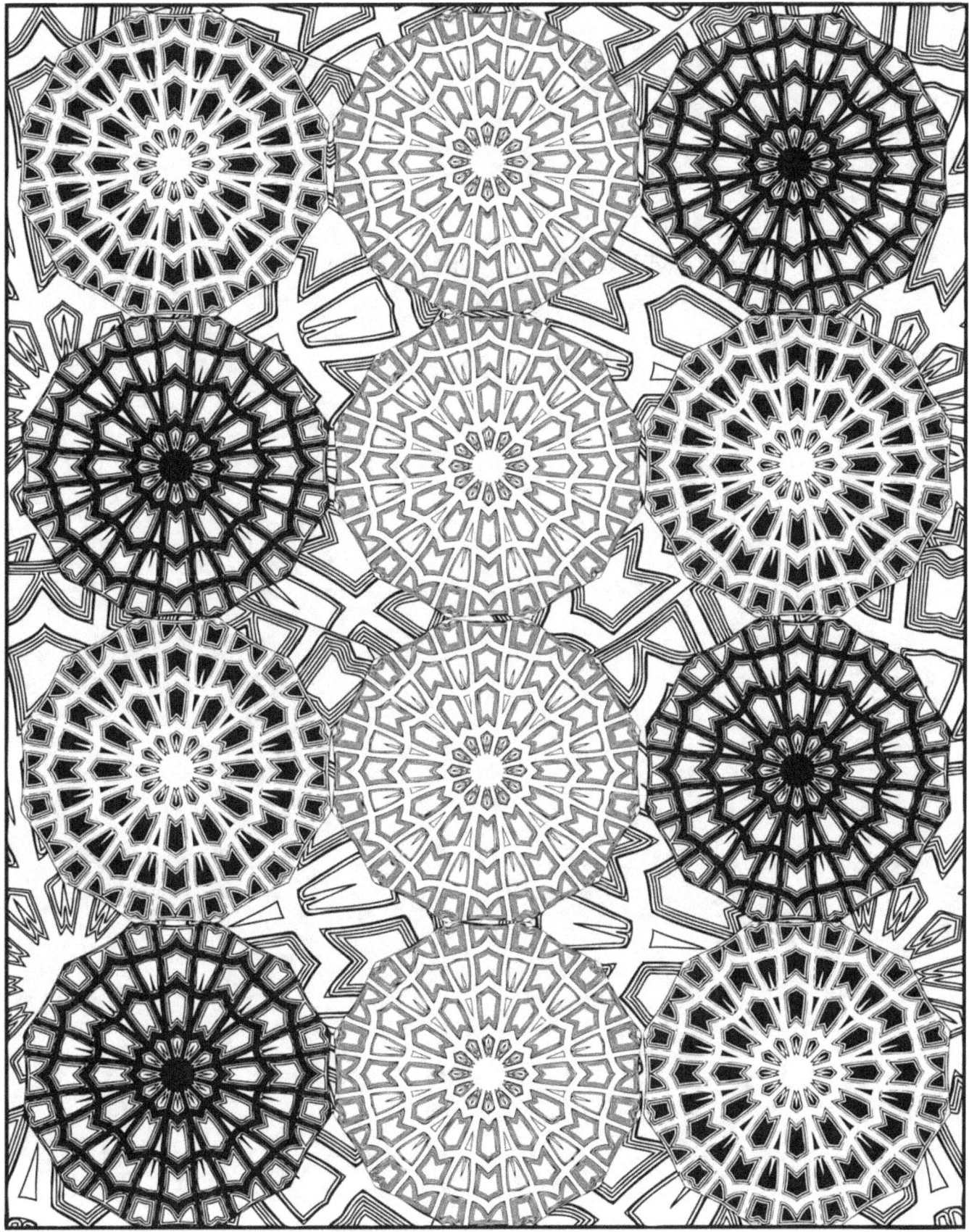

The universe will reward you for taking risks on its behalf.

- Shakti Gawain -

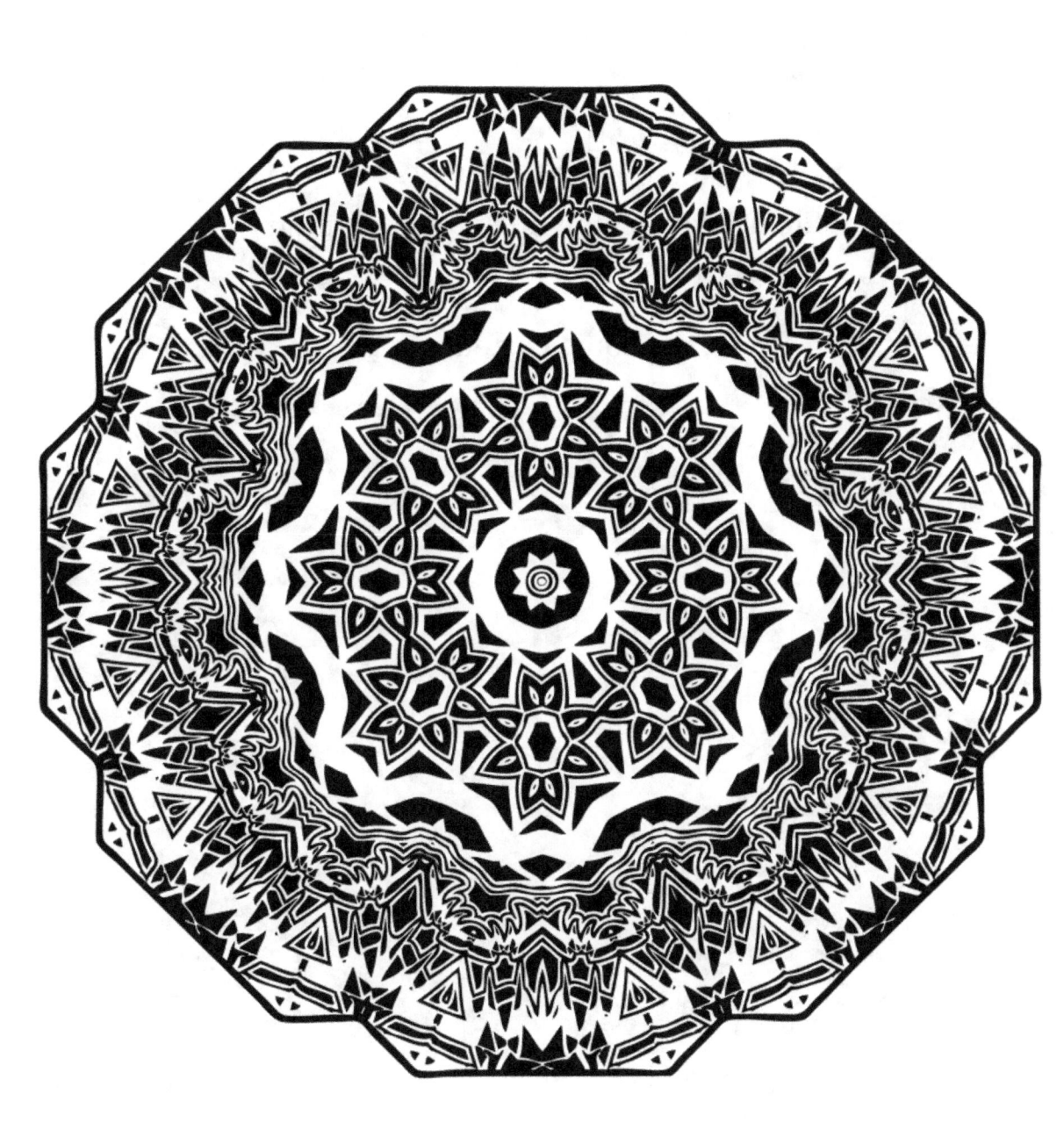

Chance favors only the prepared mind.

- Louis Pasteur -

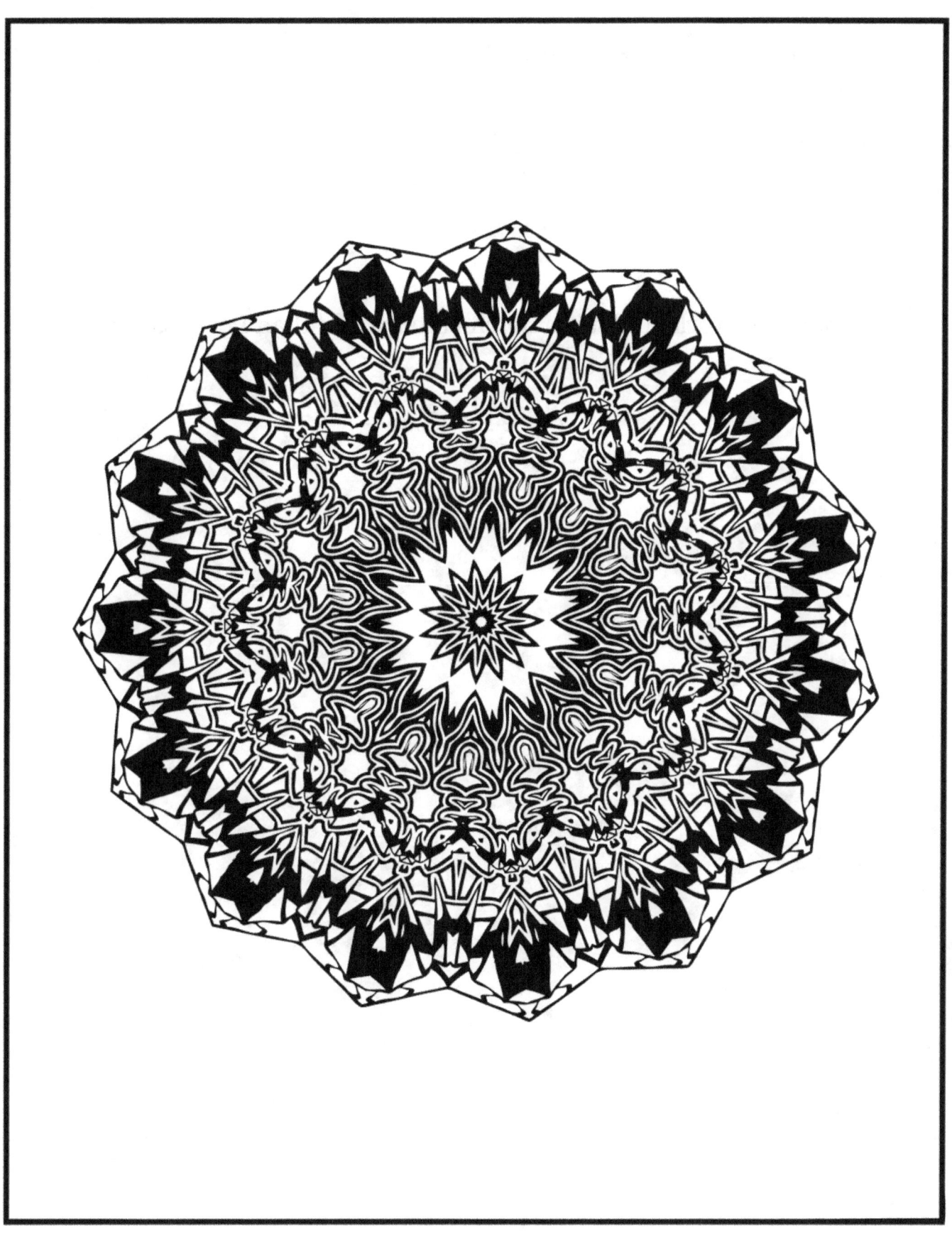

I have made my world and it is a much better world than I ever saw outside.

- Louise Nevelson –

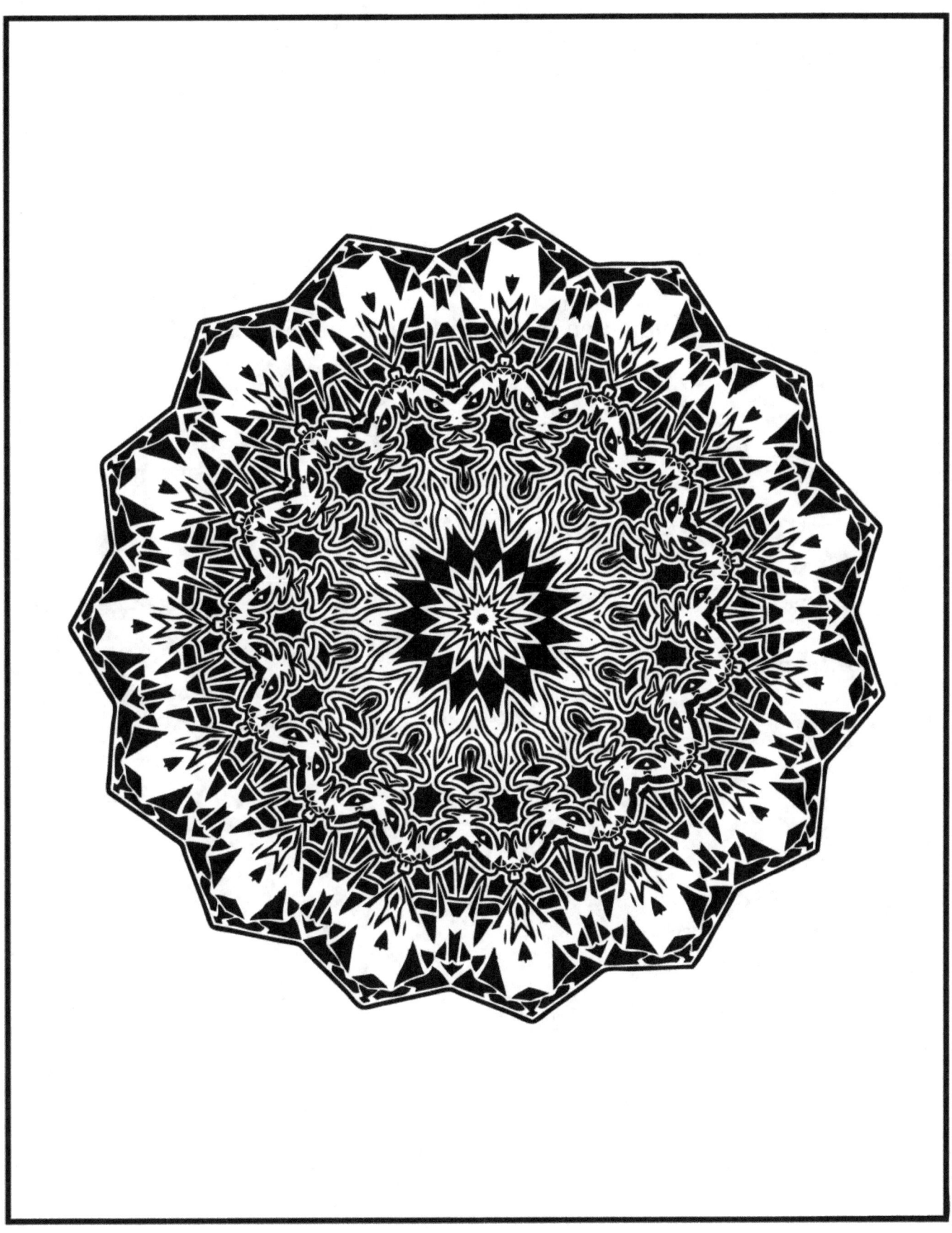

The words that enlighten the soul are more precious than jewels.

- Hazrat Inayat Khan –

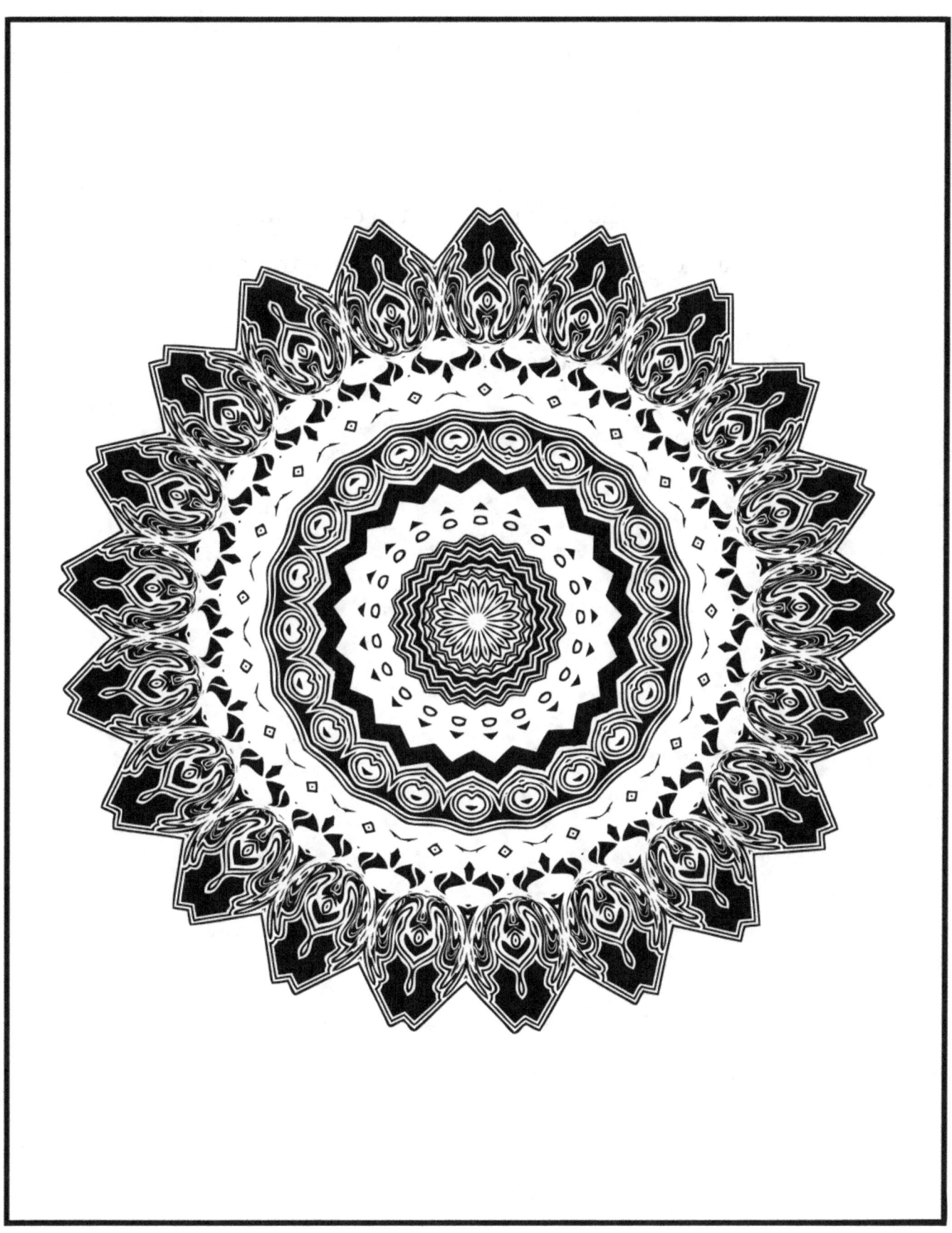

Artists who seek perfection in everything
are those who cannot attain it in anything.

- Eugéne Delacroix -

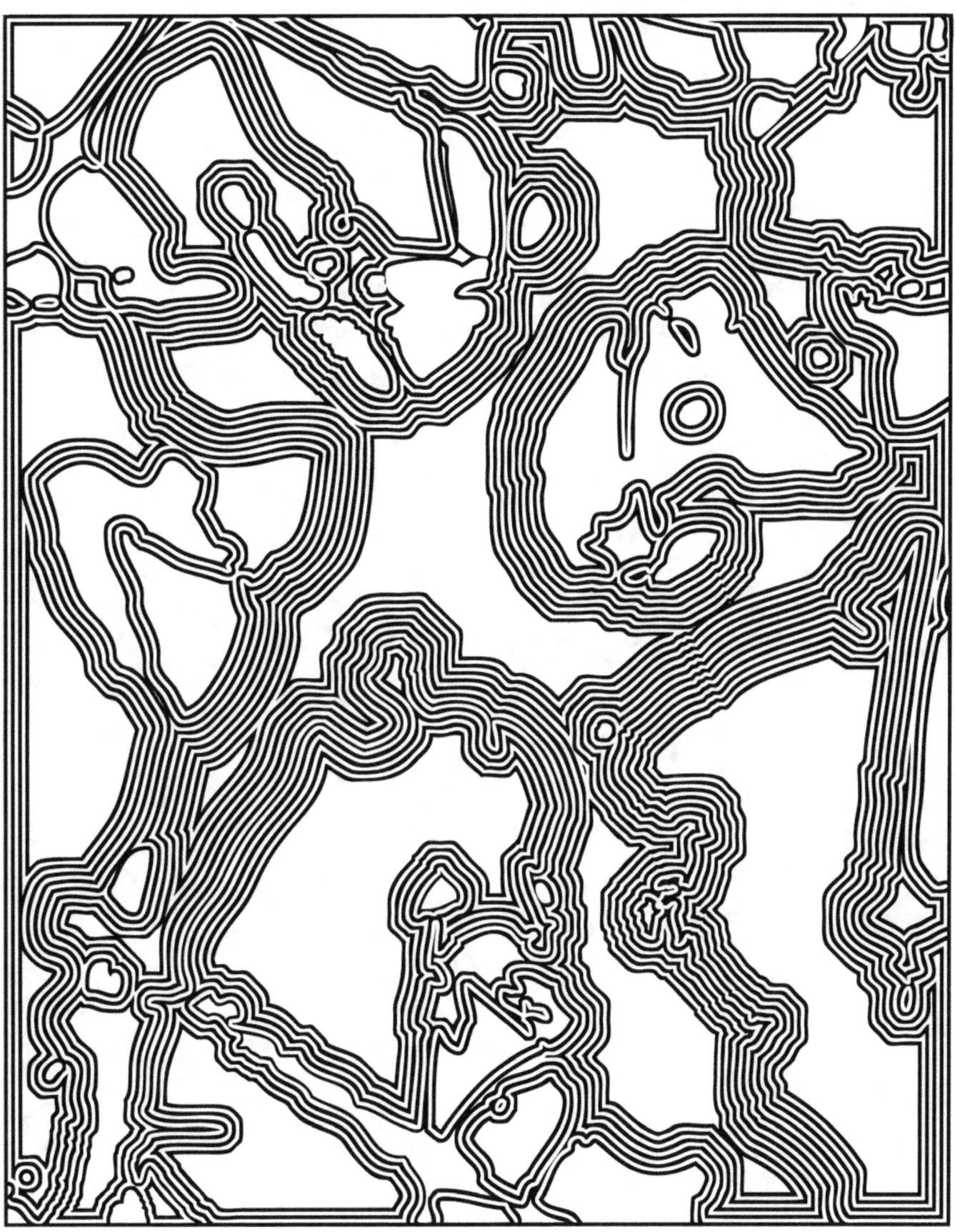

Whenever I have to choose between two evils,

I always like to try the one I haven't tried before.

- Mae West -

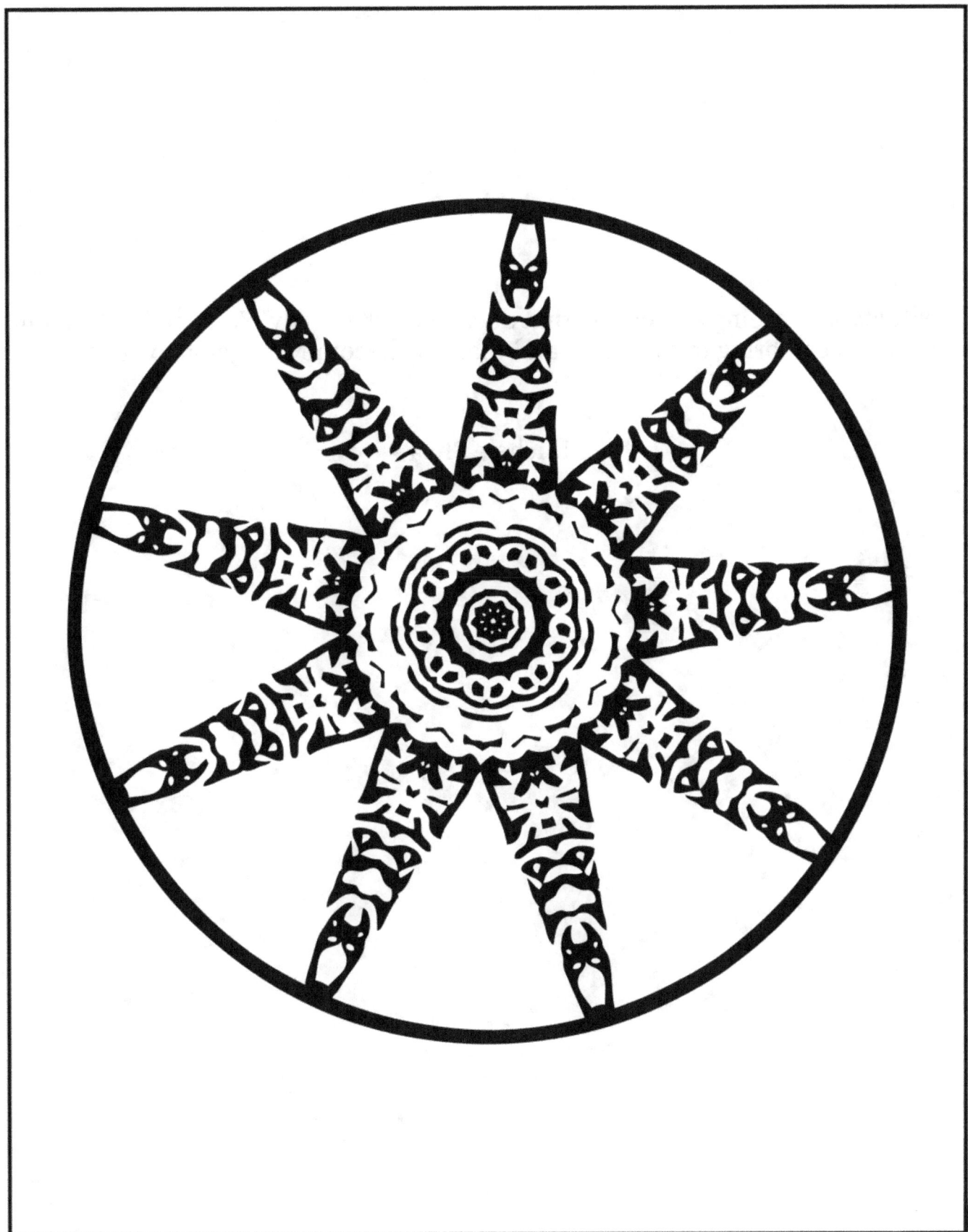

Creativity is ... seeing something that doesn't exist already. You need to find out how you can bring it into being and that way become a playmate with God.

- Michele Shea -

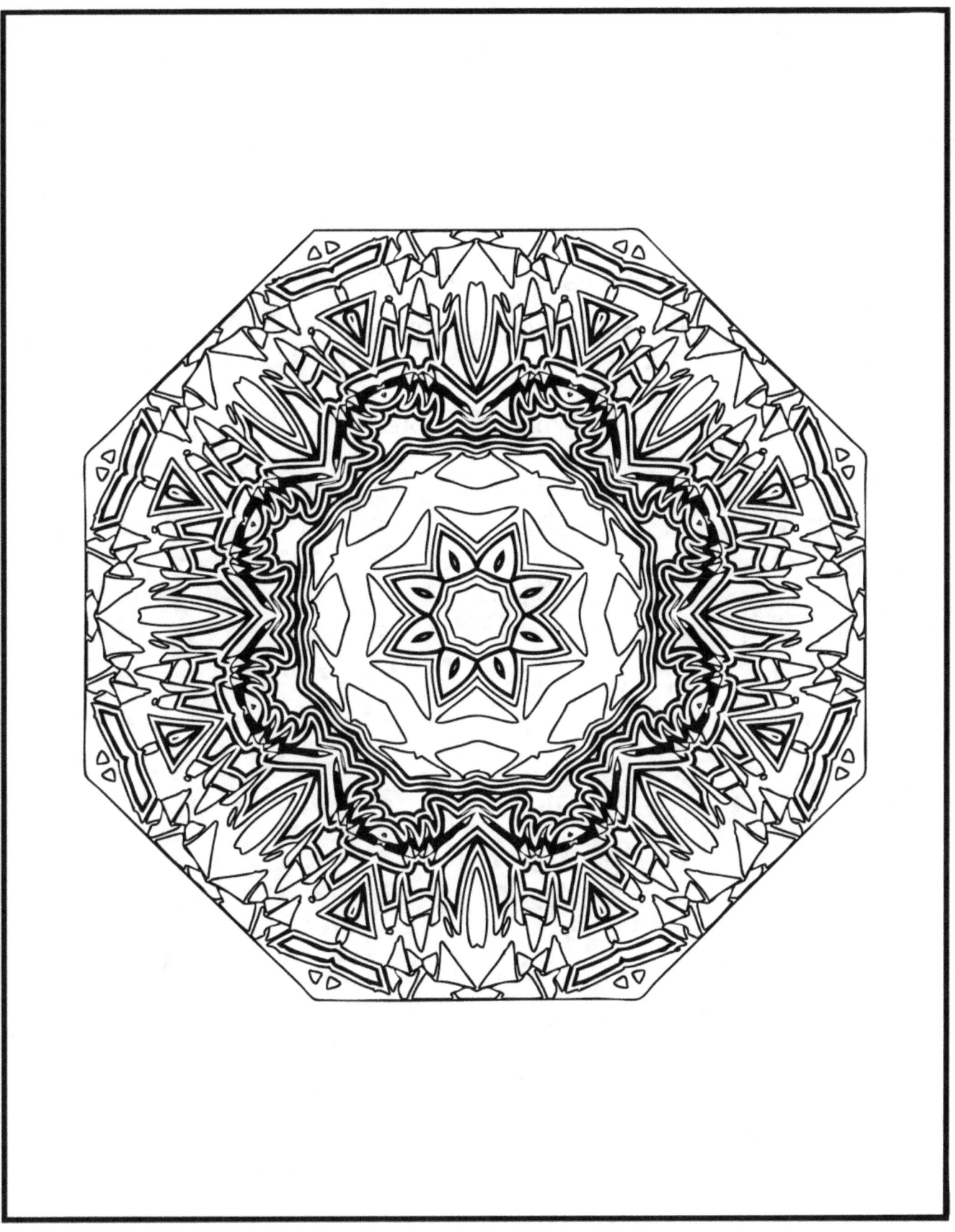

Each painting has its own way of evolving.
When it is finished, the subject reveals itself.

- William Baziotes -

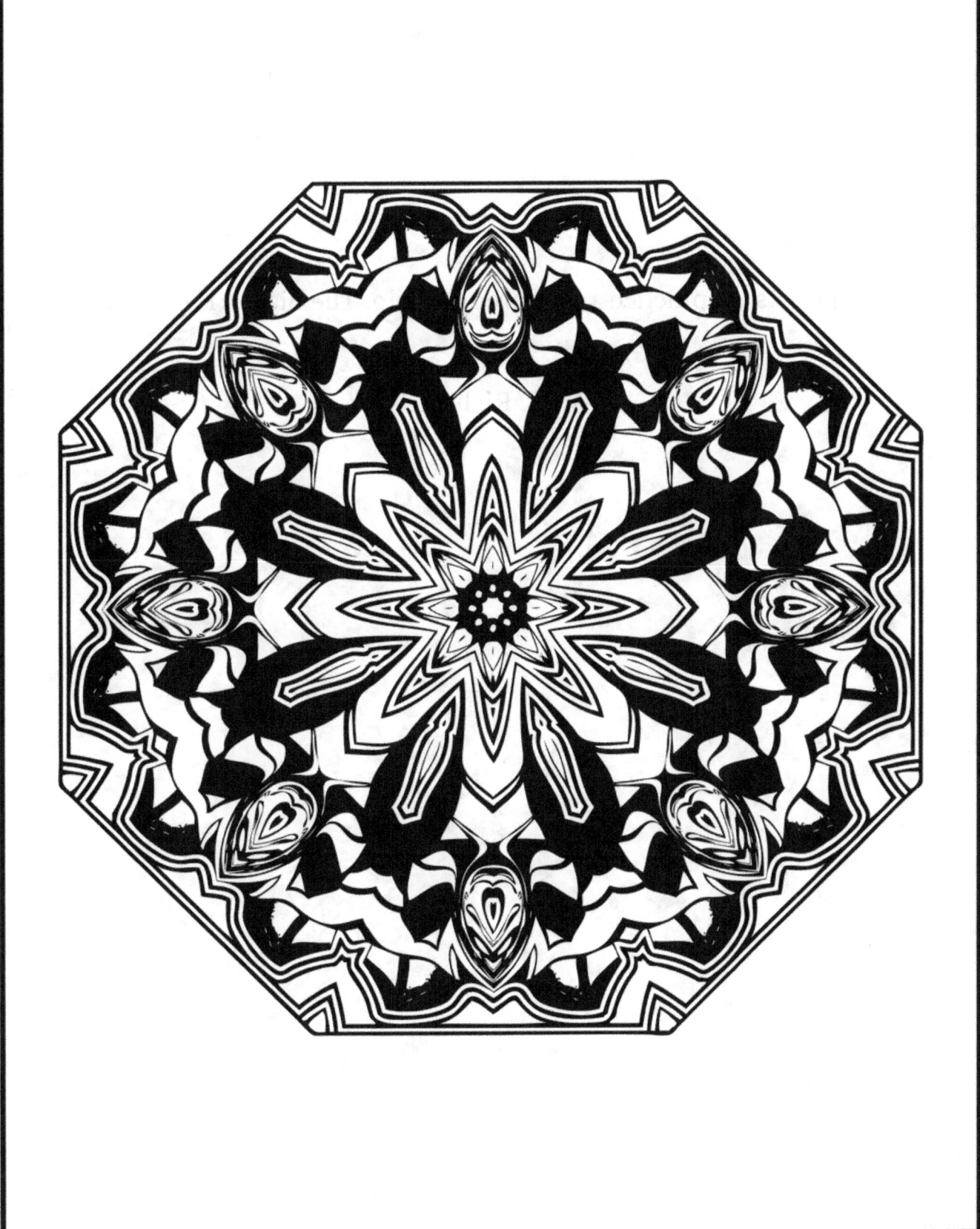

All the arts we practice are apprenticeship. The big art is our life.

- M. C. Richards -

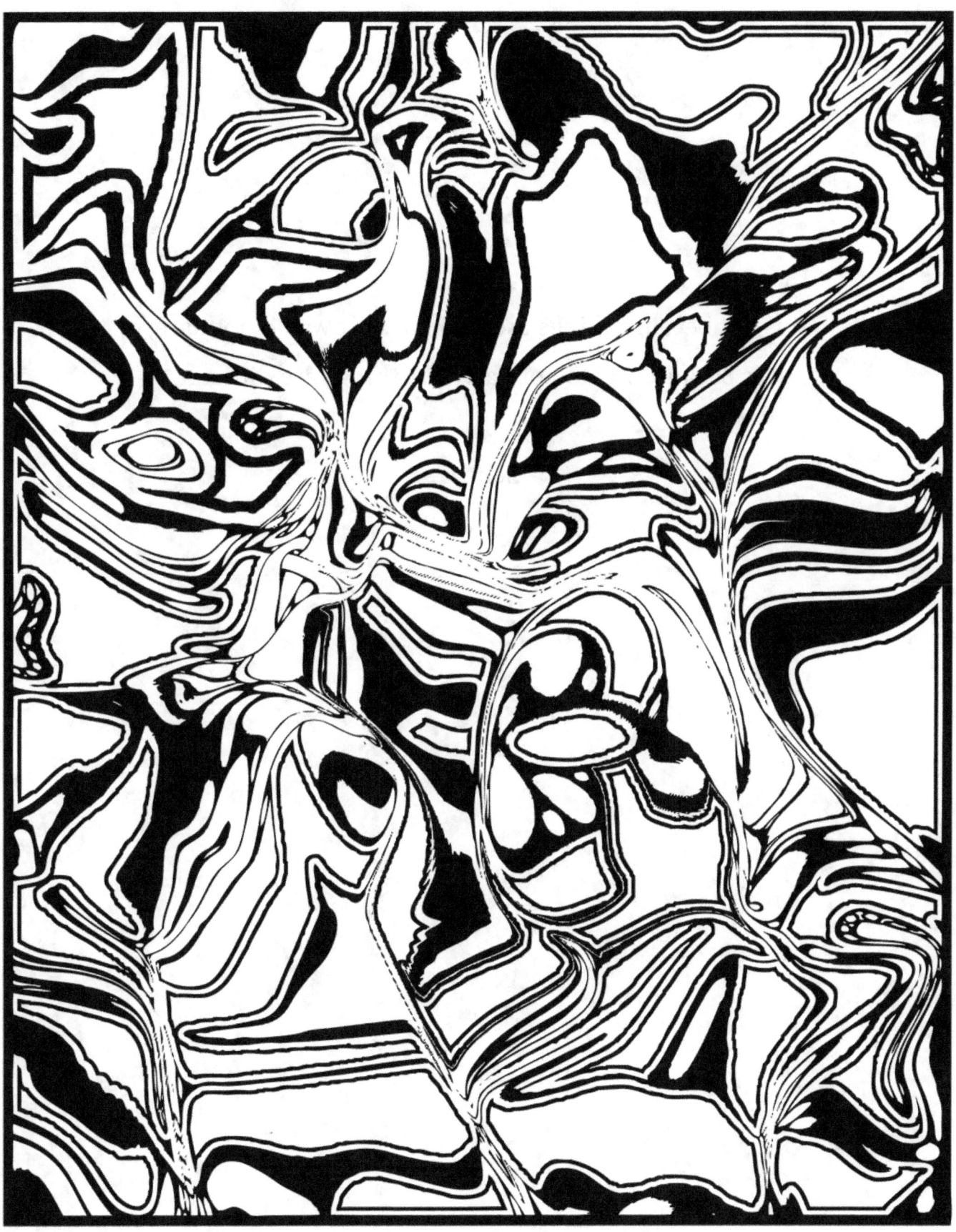

It is not because things are difficult that we do not dare;

it is because we do not dare that things are difficult.

- Seneca -

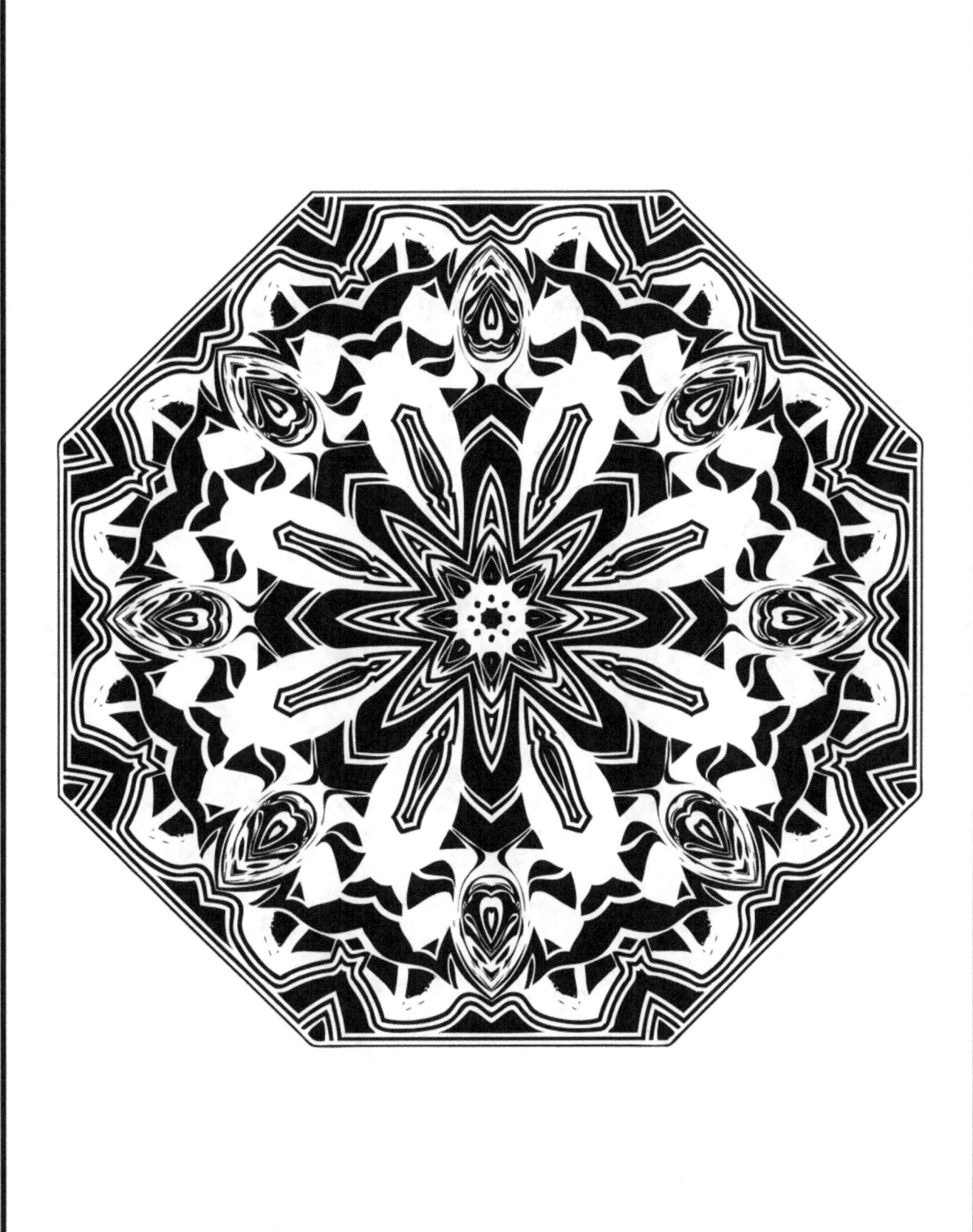

In a dark time, the eye begins to see.

- Theodore Roethke -

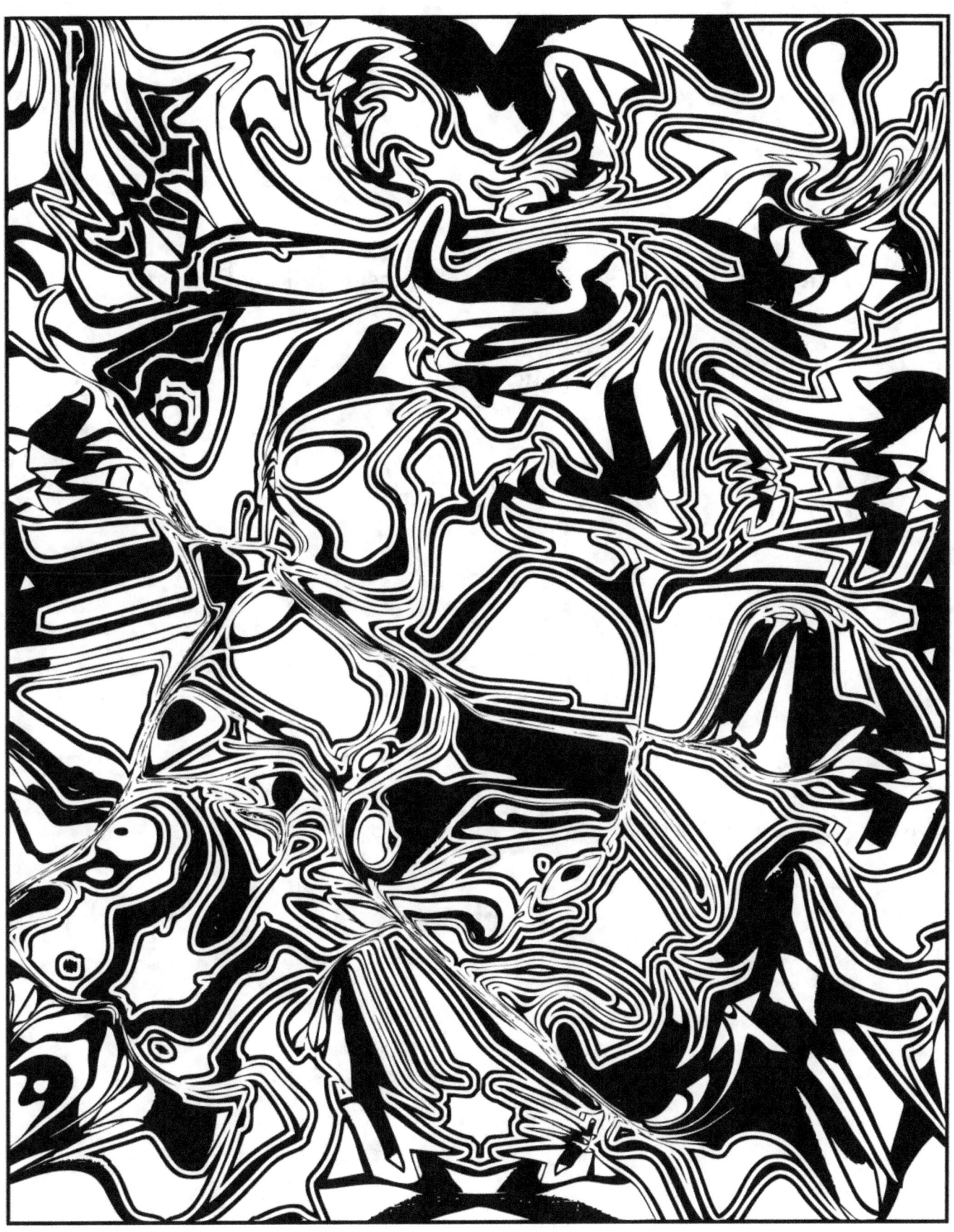

That desire to make something is God inside talking through us.

- Michele Shea -

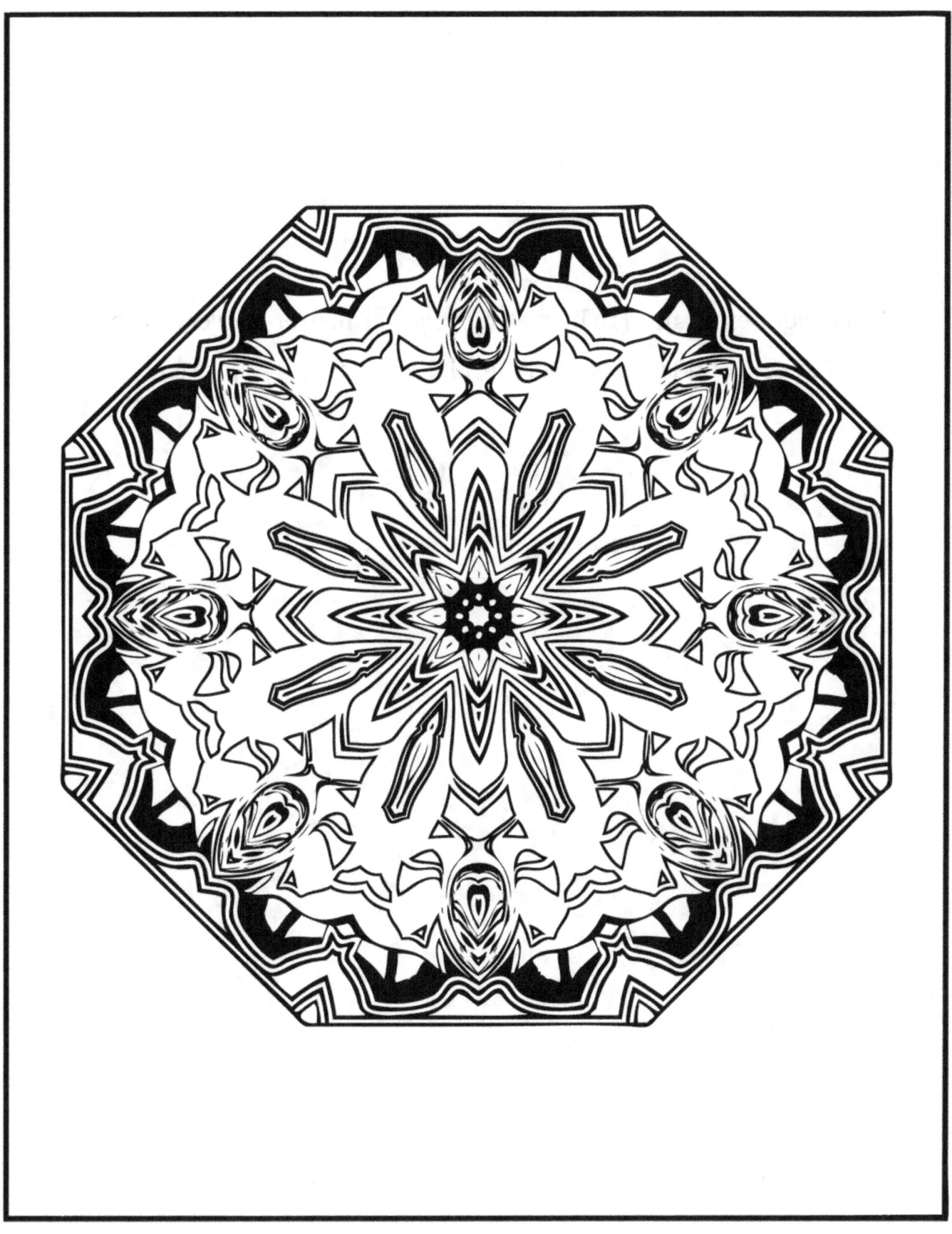

Expect your every need to be met. Expect the answer to every problem. Expect abundance on every level. Expect to grow spiritually.

- Eileen Caddy -

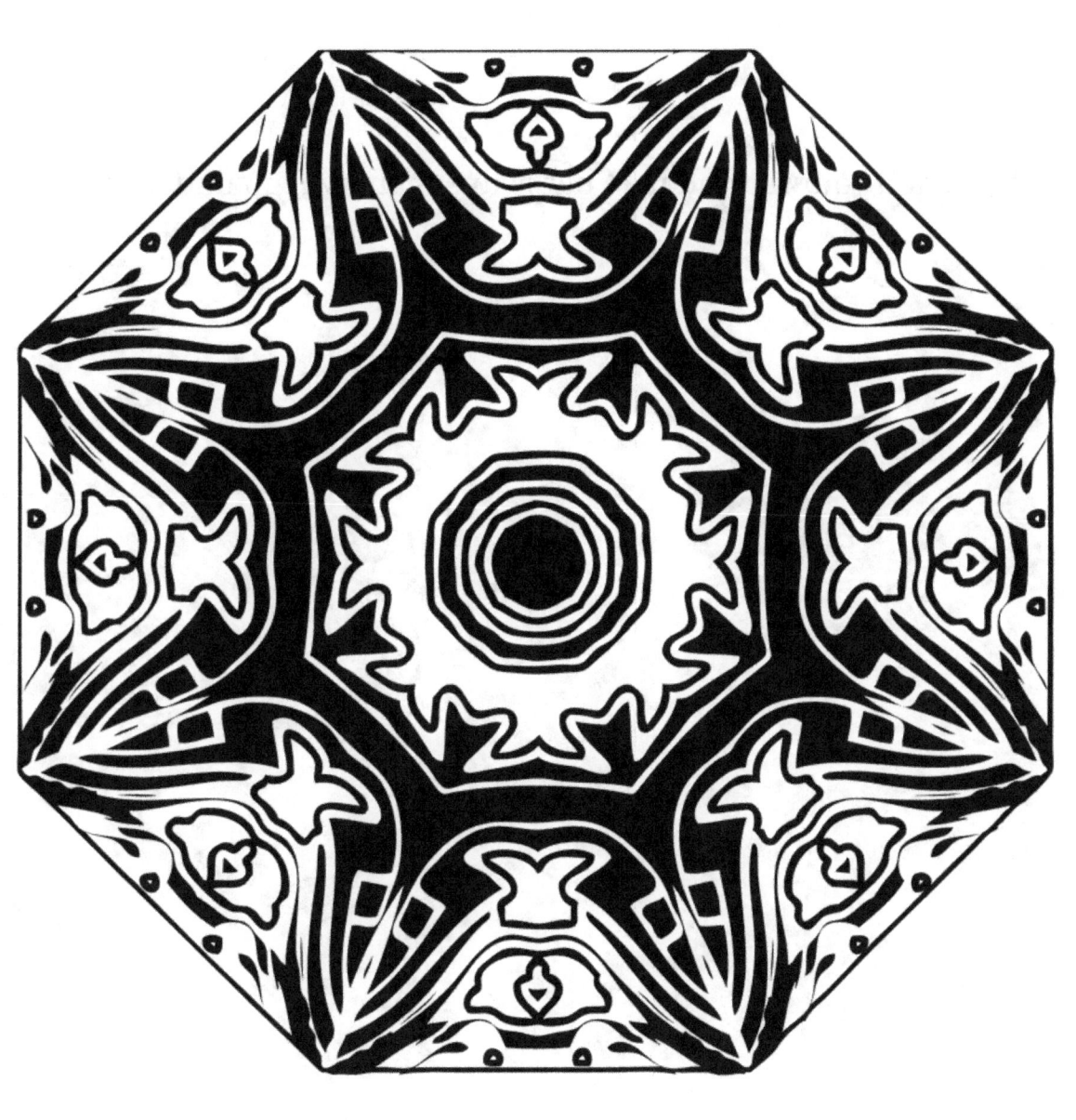

Look and you will find it. What is unsought will go undetected.

- Sophocles -

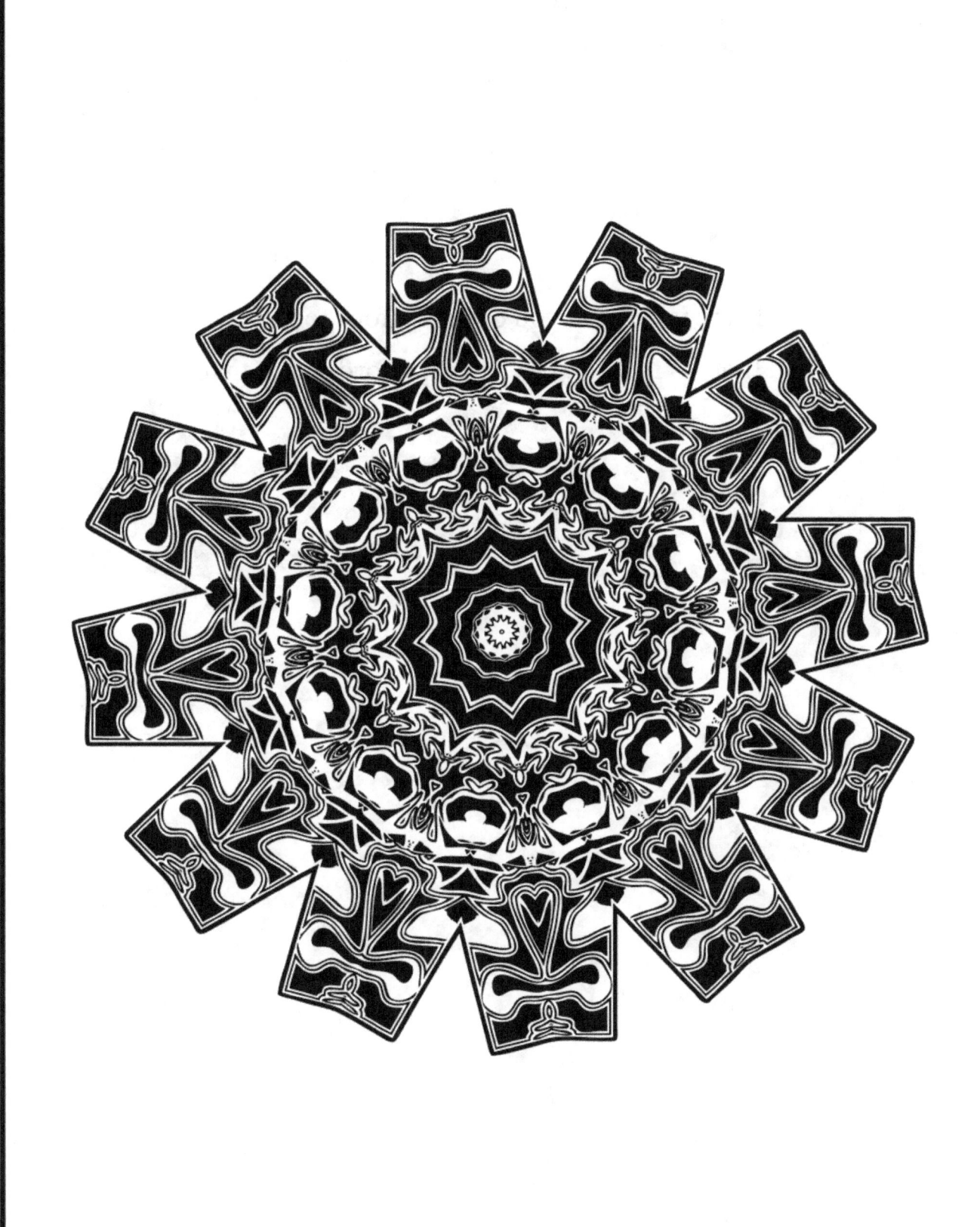

There is the risk you cannot afford to take,
and there is the risk you cannot afford not to take.

- Peter Drucker -

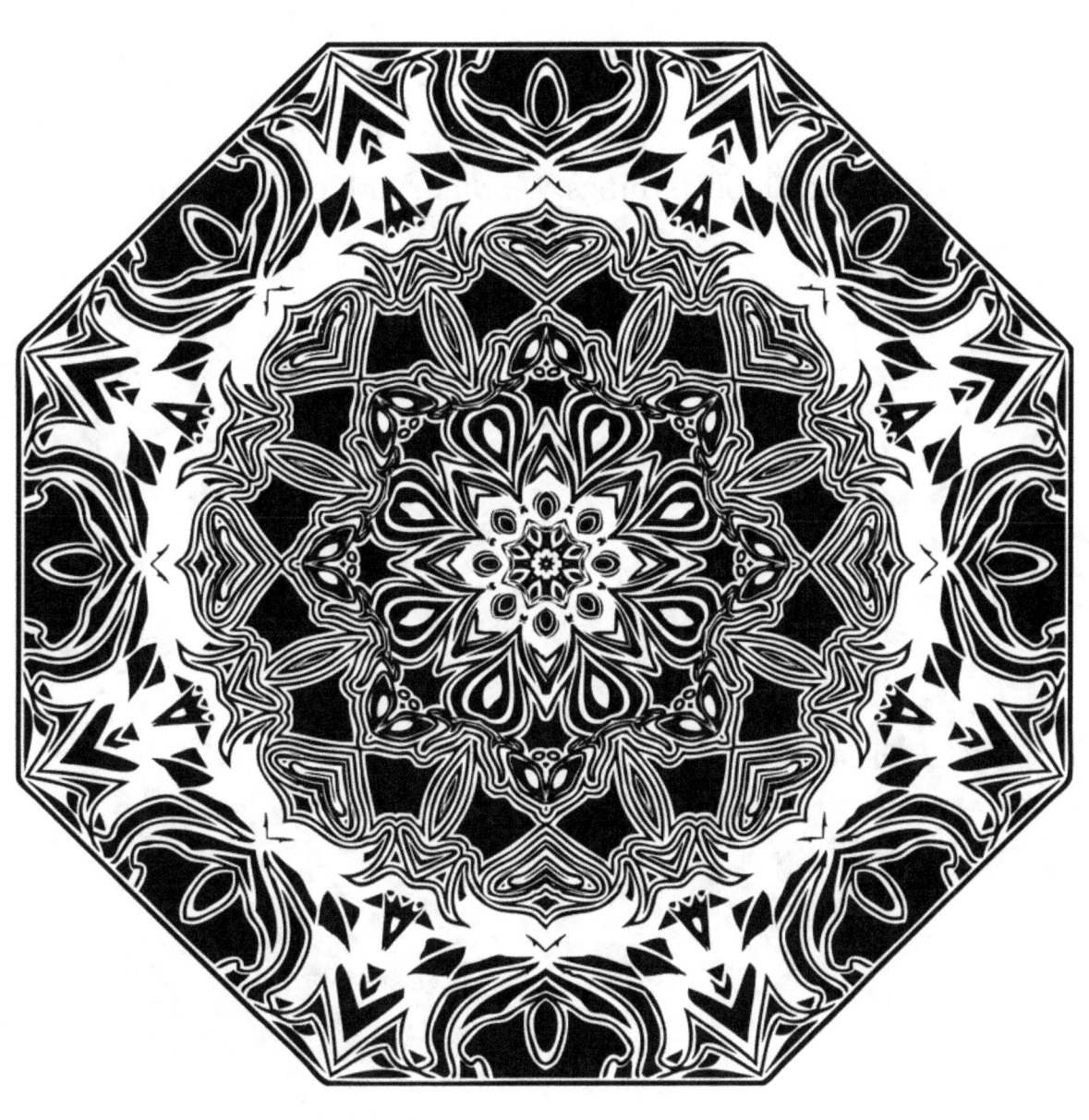

You will do foolish things. Do them with enthusiasm.

- Colette -

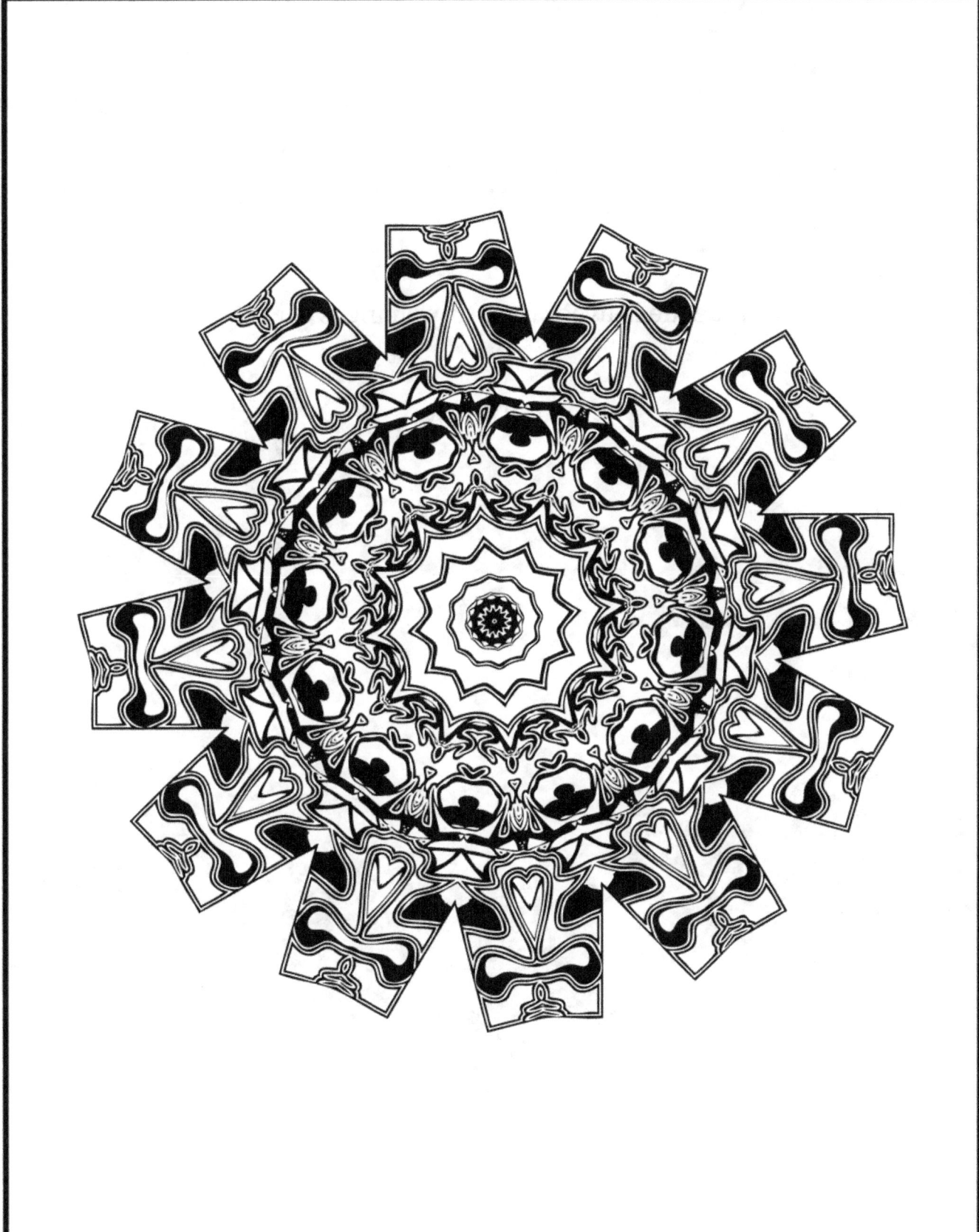

True life is lived when tiny changes occur.

- Leo Tolstoy -

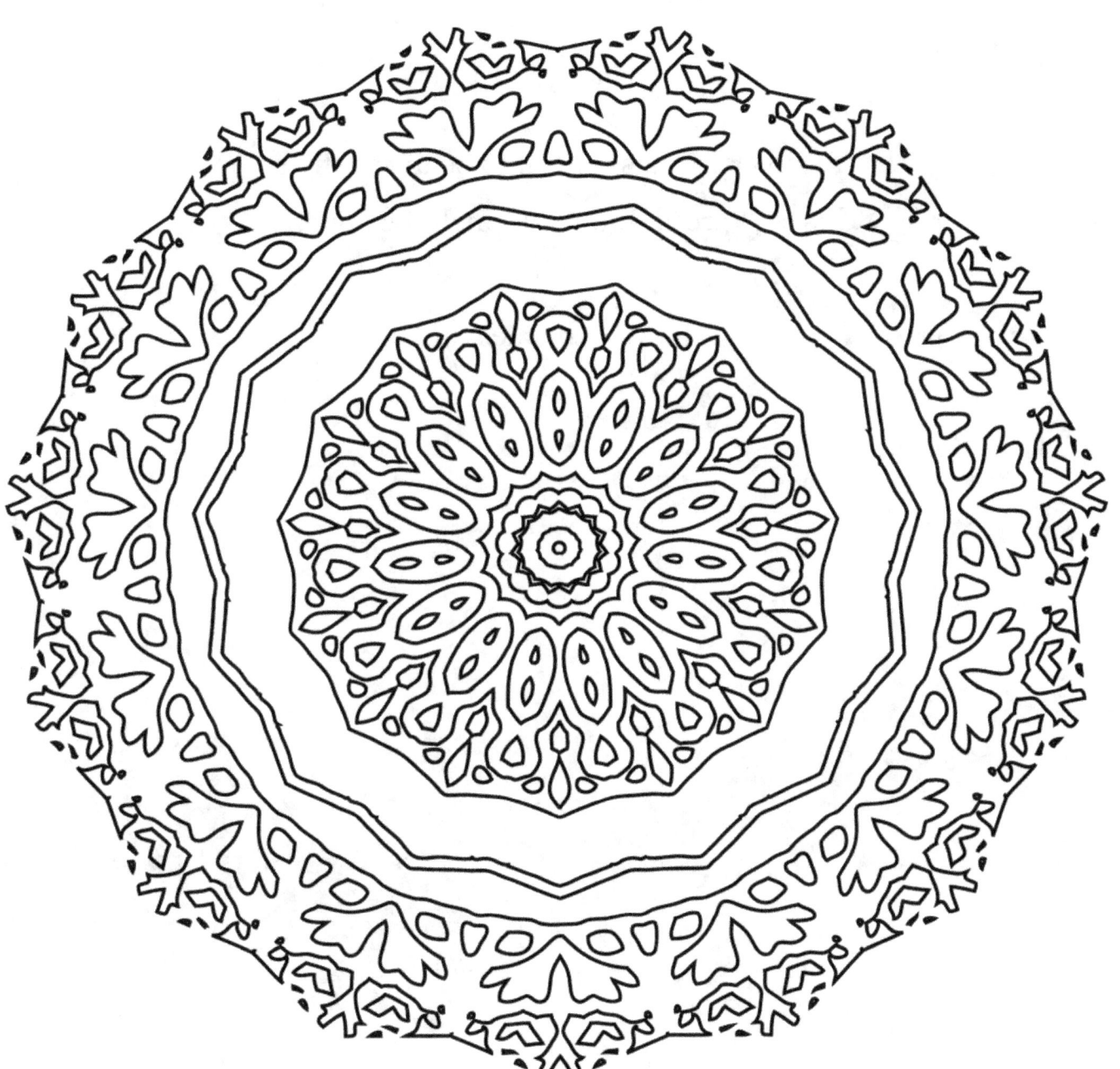

As an artist, it is central to be unsatisfied.

This isn't greed, though it might be appetite.

- Lawrence Calcagno -

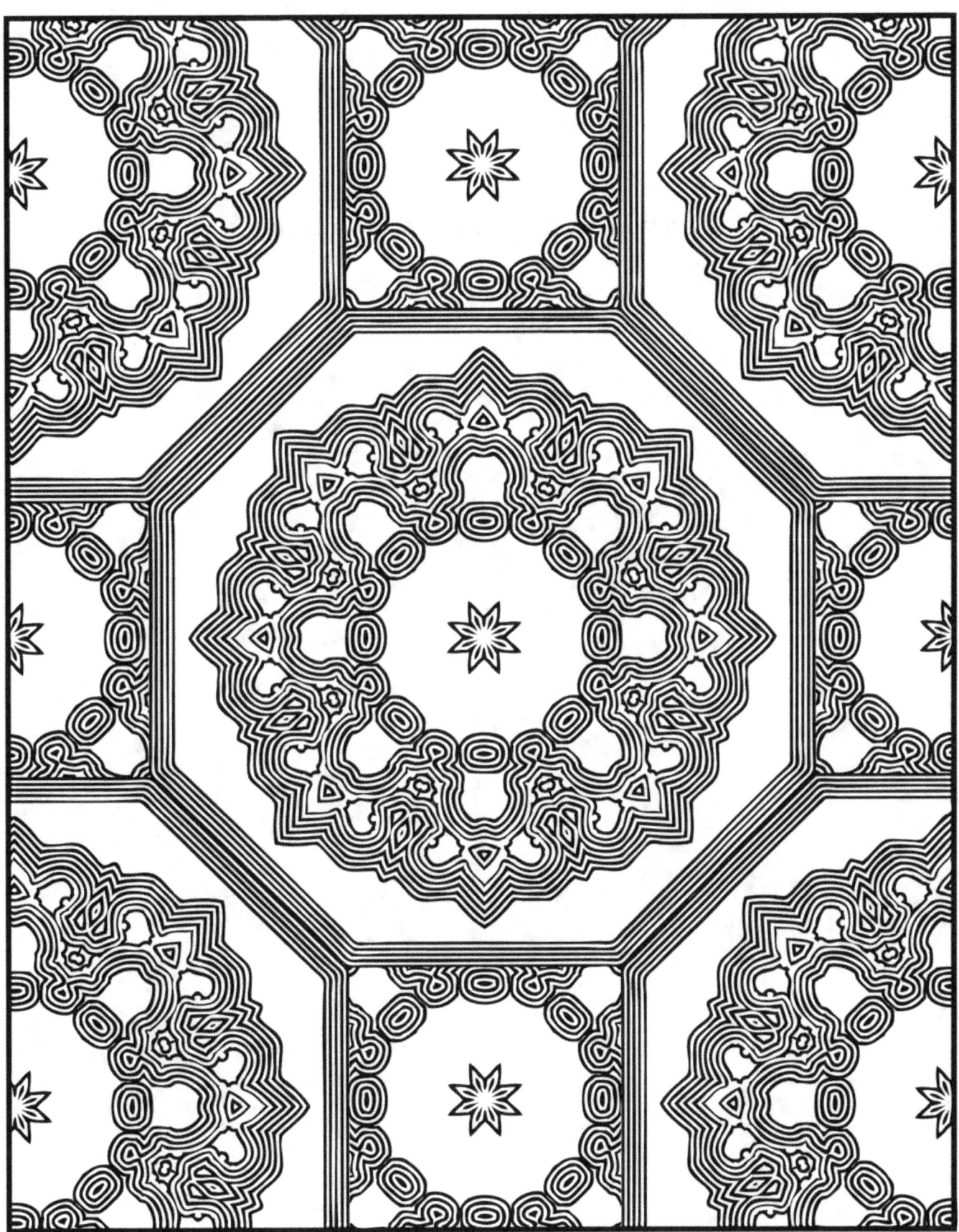

Cerebration is the enemy of originality in art.

- Martin Ritt -

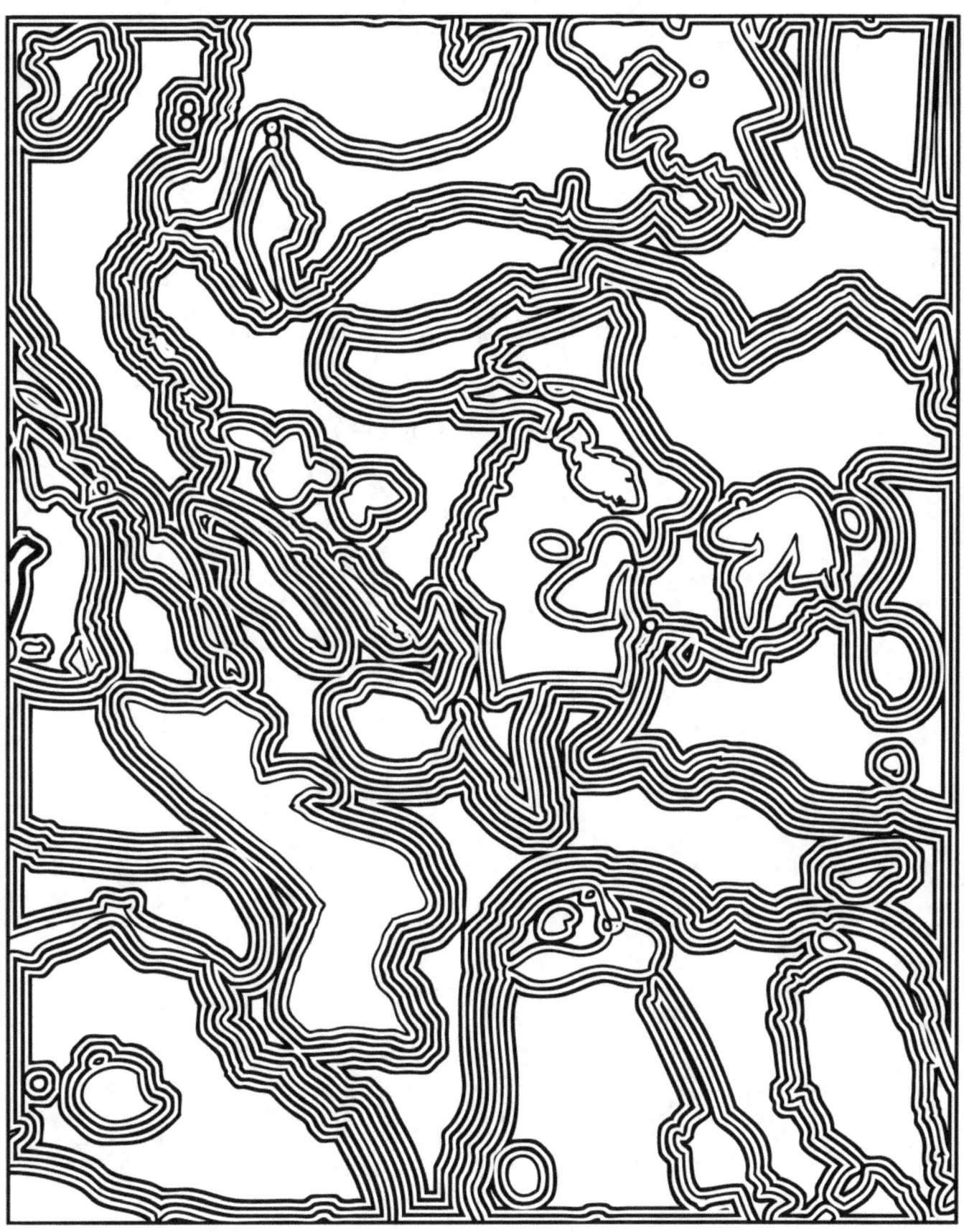

I would rather die of passion than of boredom.

- Vincent van Gogh –

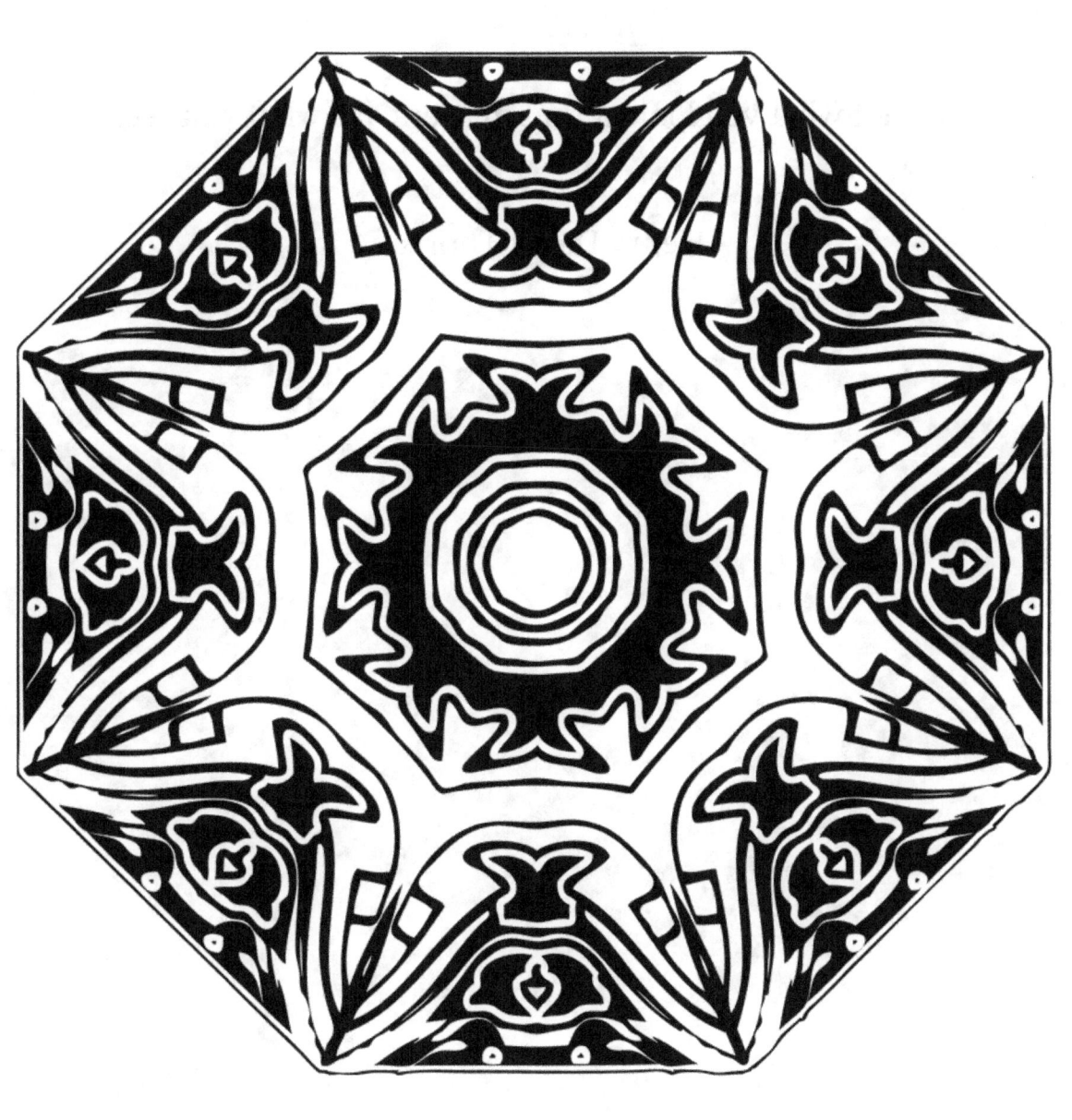

It's not what you look at that matters, it's what you see.

- Henry David Thoreau -

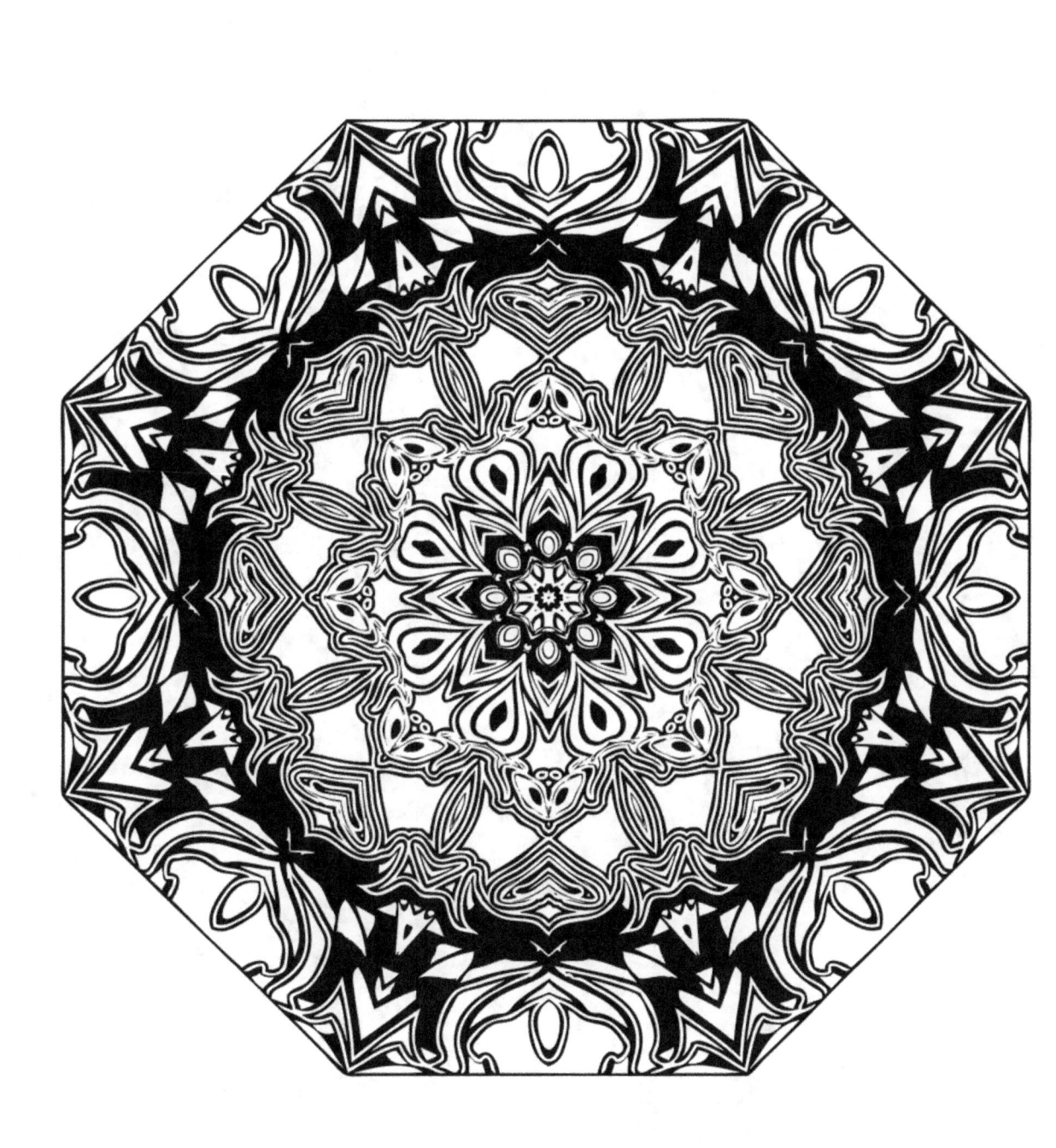

Inspiration does exist, but it must find you working.

- Pablo Picasso -

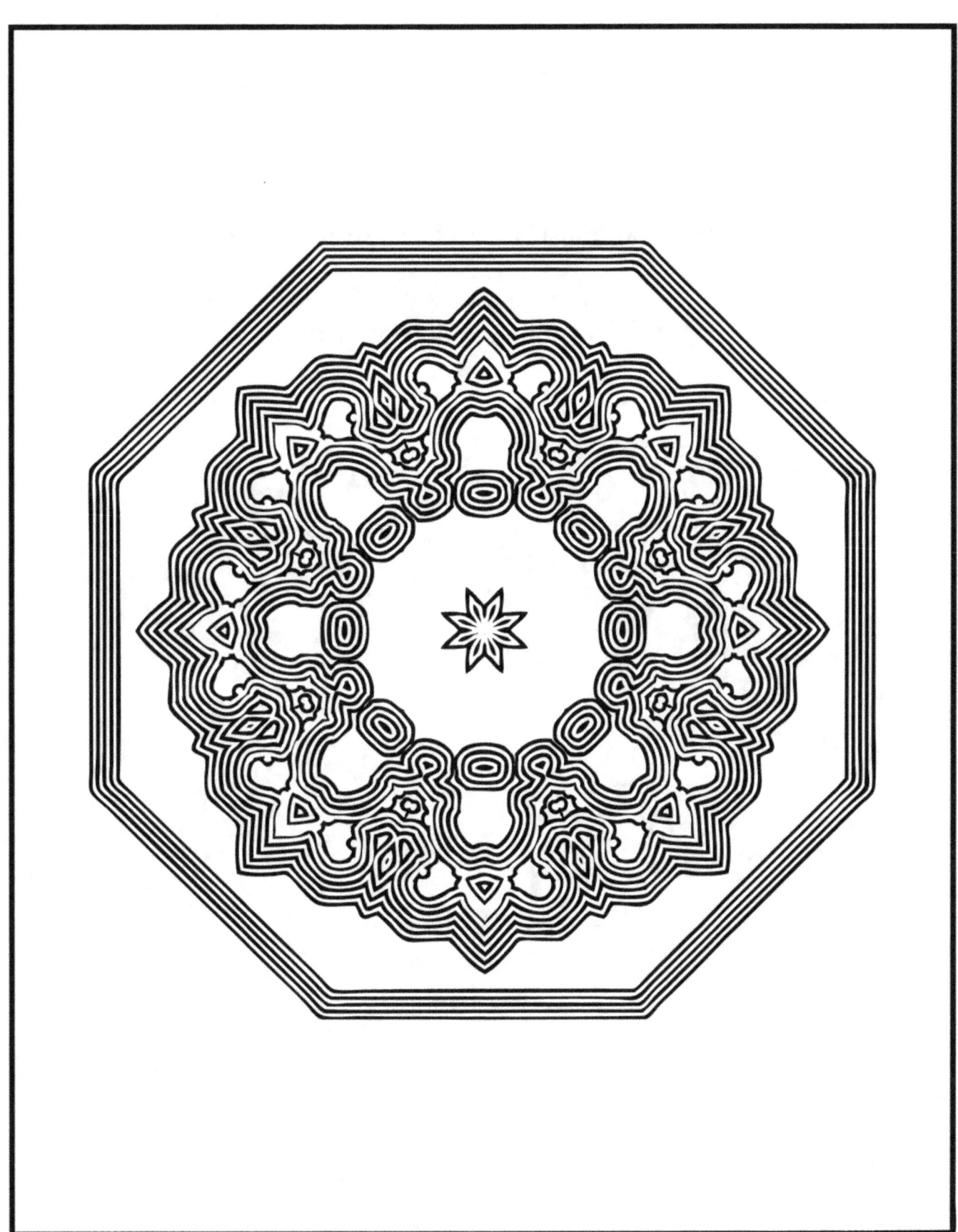

There is no "must" in art, because art is free.

- Wassily Kandinsky -

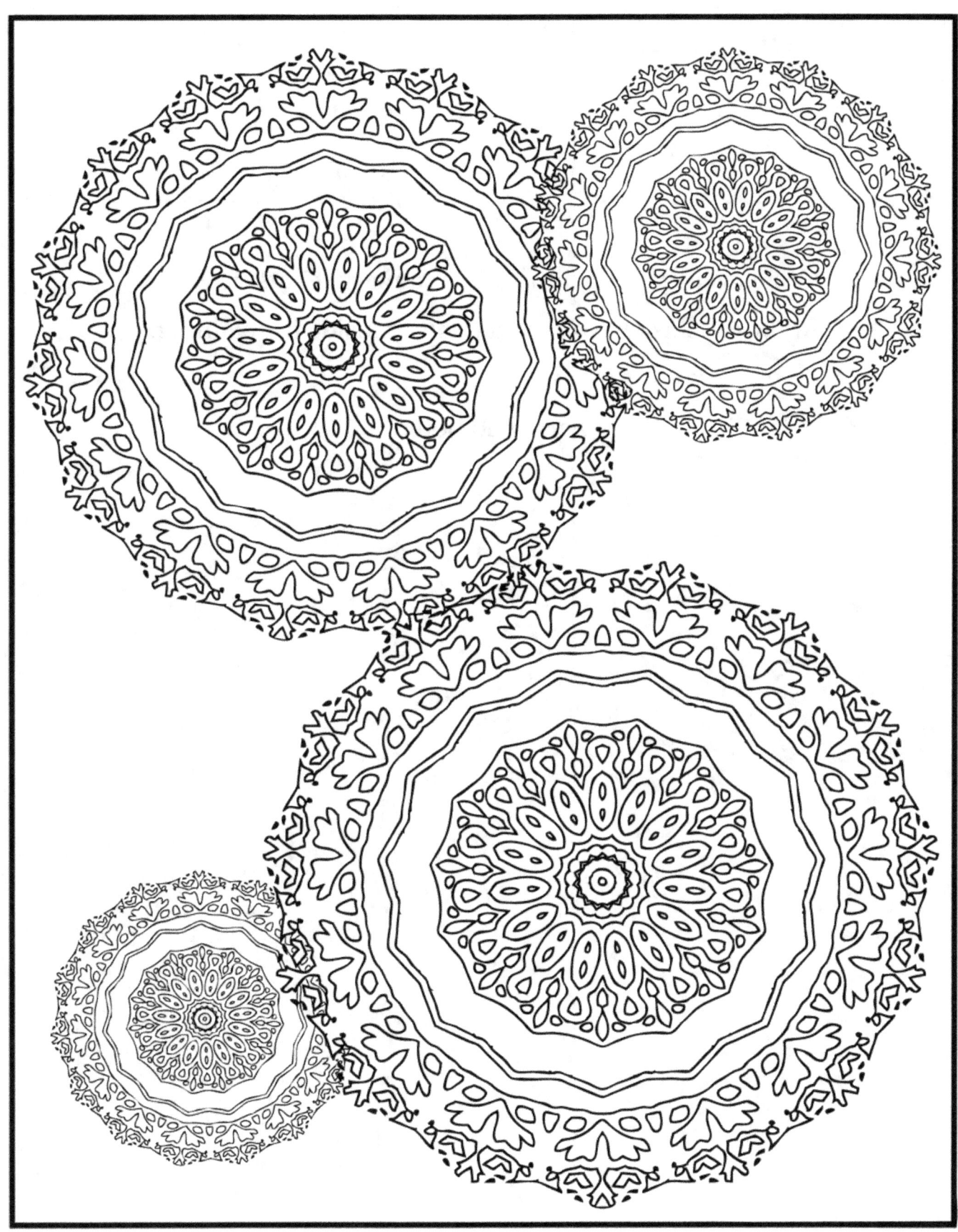

When you start a painting, it is somewhat outside you.
At the conclusion, you seem to move inside the painting.

- Fernando Botero -

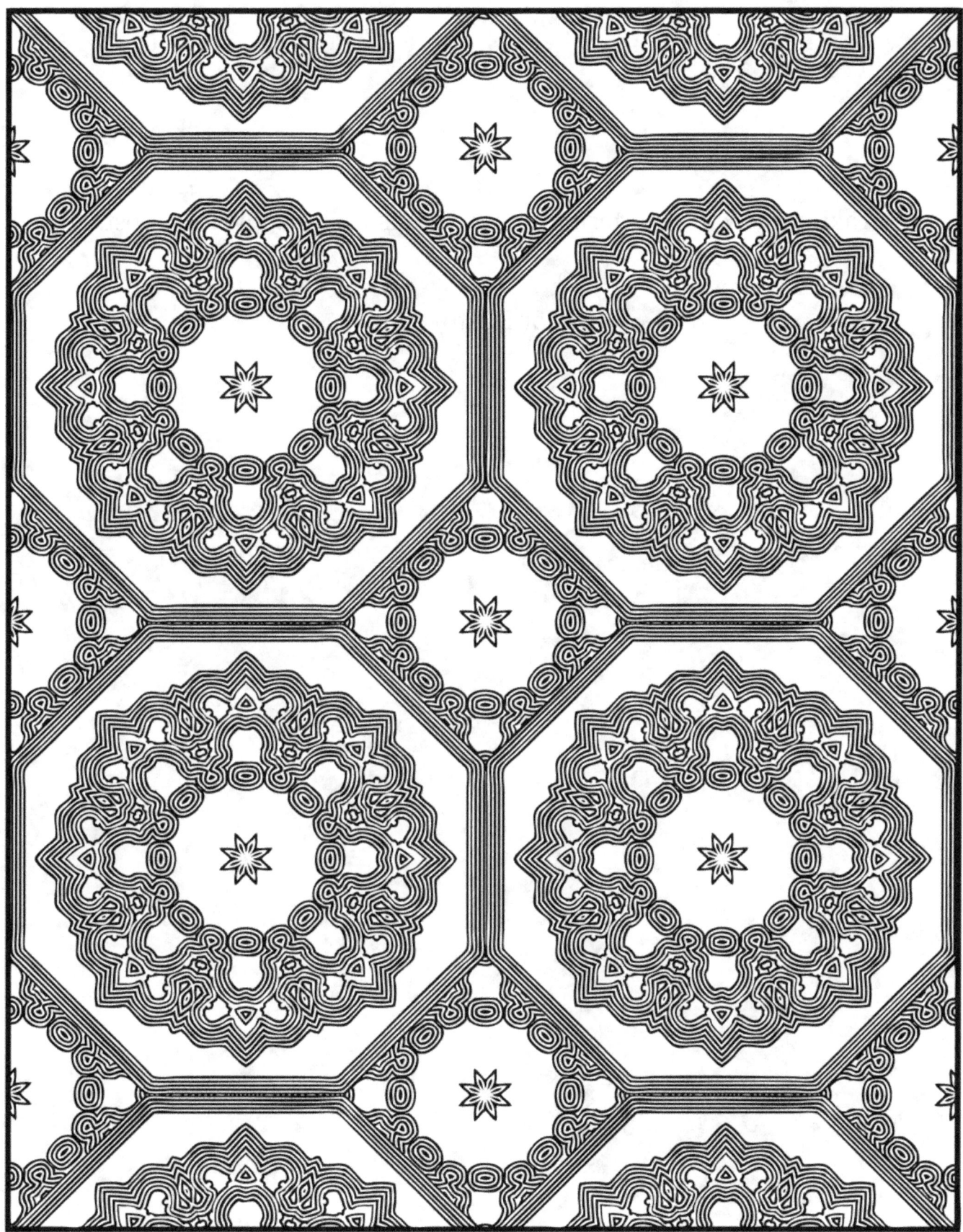

Taking a new step, uttering a new word is what people fear most.

- Fyodor Dostoyevski -

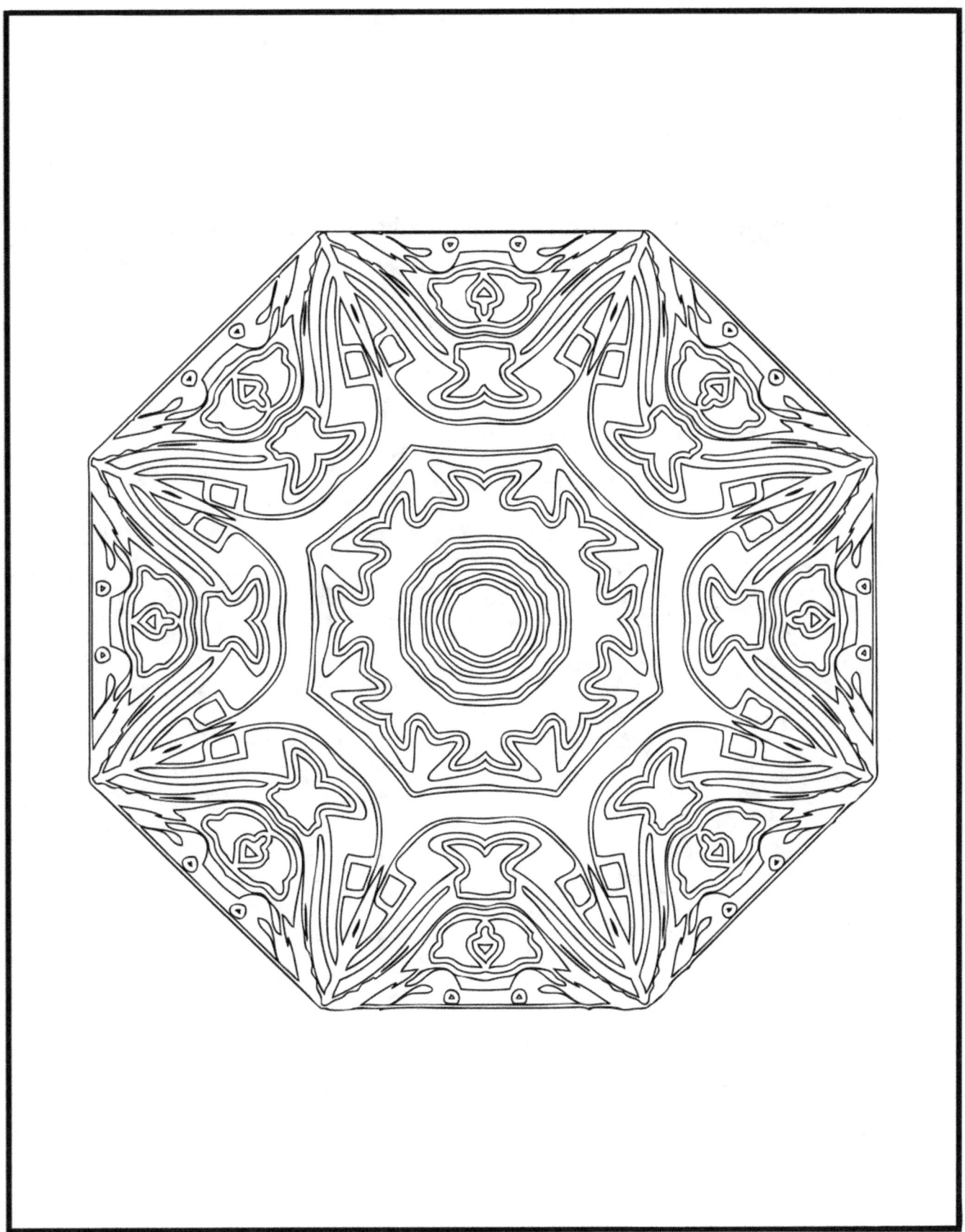

The world of reality has its limits. The world of imagination is boundless.

- Jean-Jacques Rousseau –

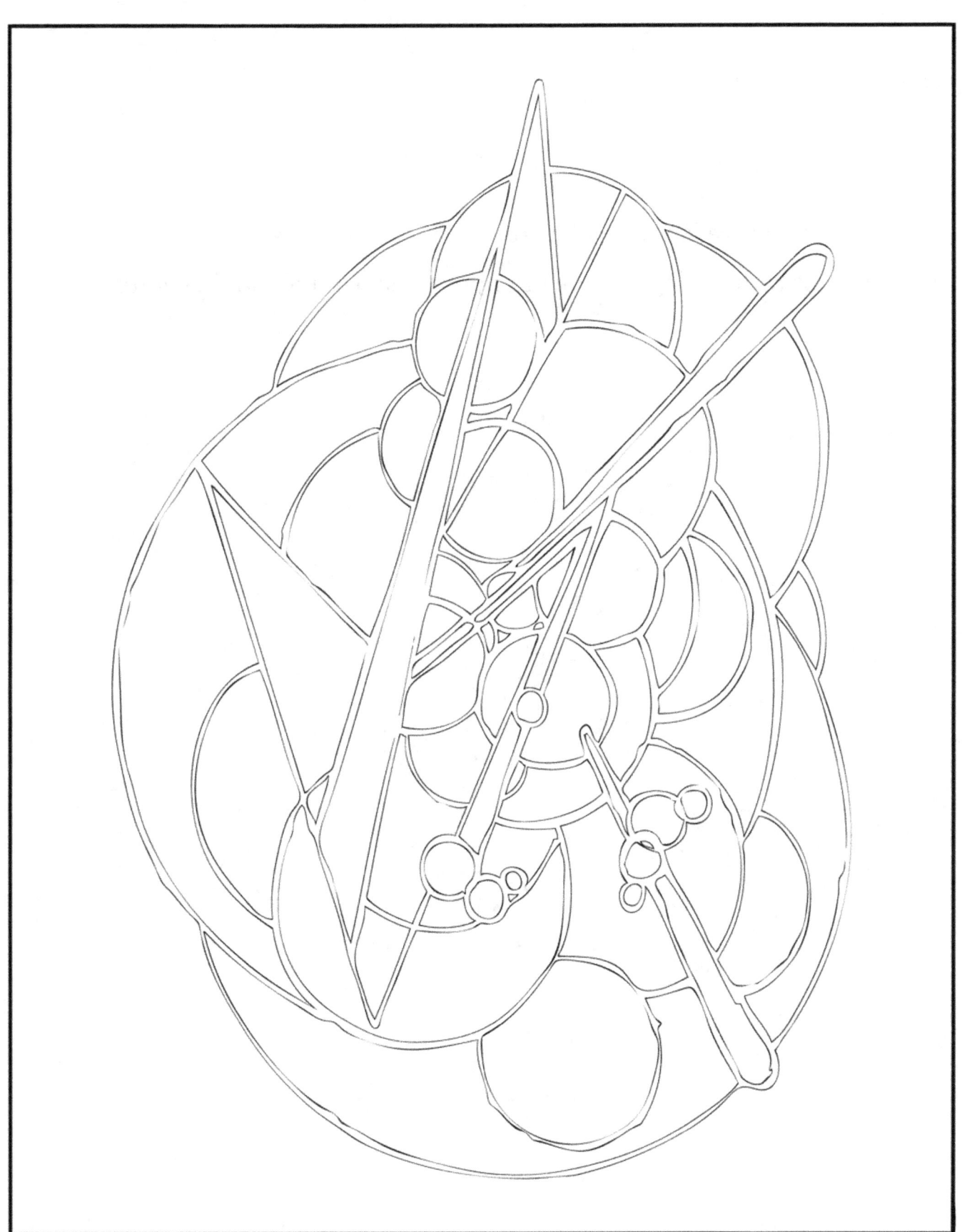

There is a logic of colors, and it is with this alone,
and not with the logic of the brain, that the painter should conform.

- Paul Cèzanne –

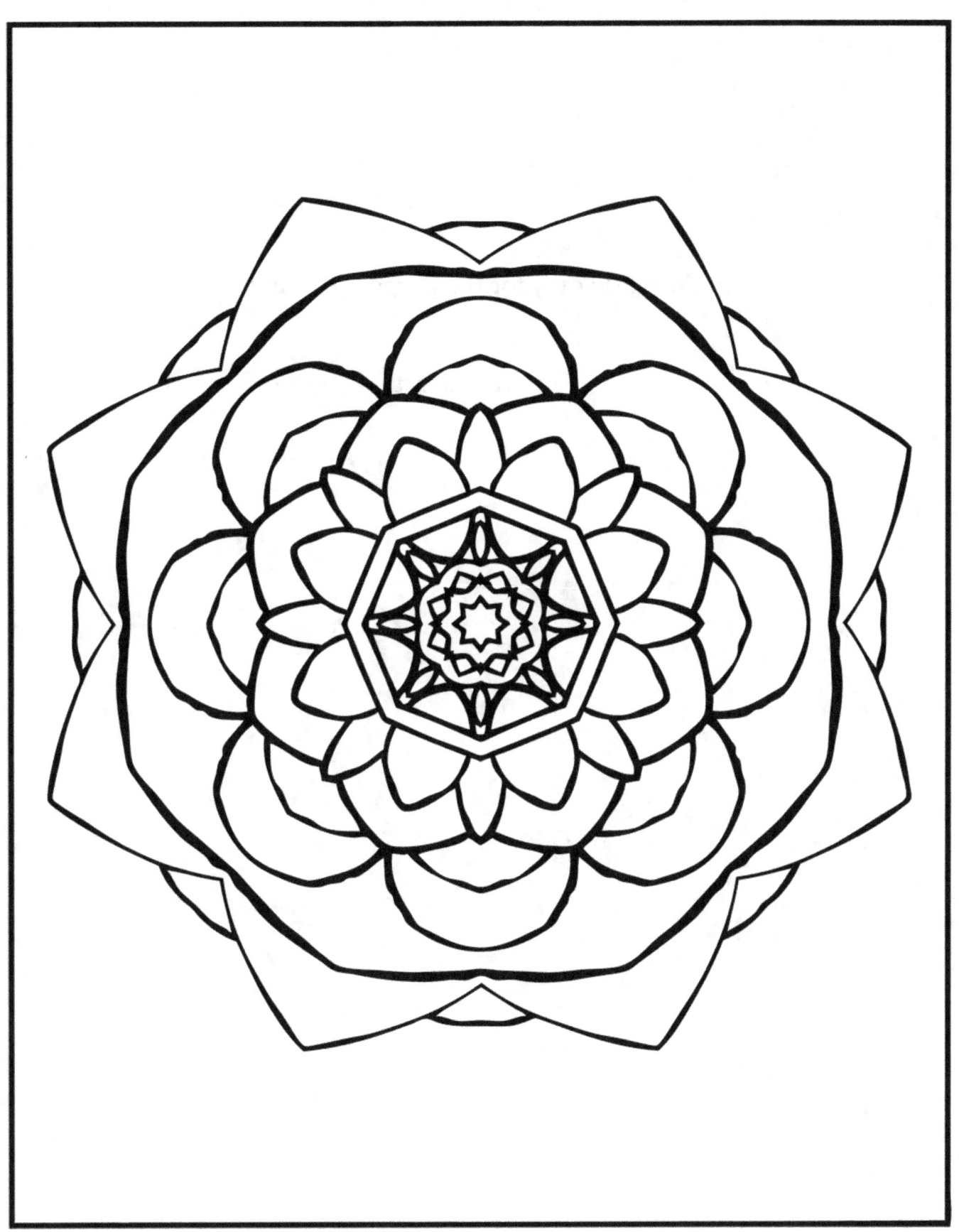

I am in the world only for the purpose of composing.

- Franz Schubert –

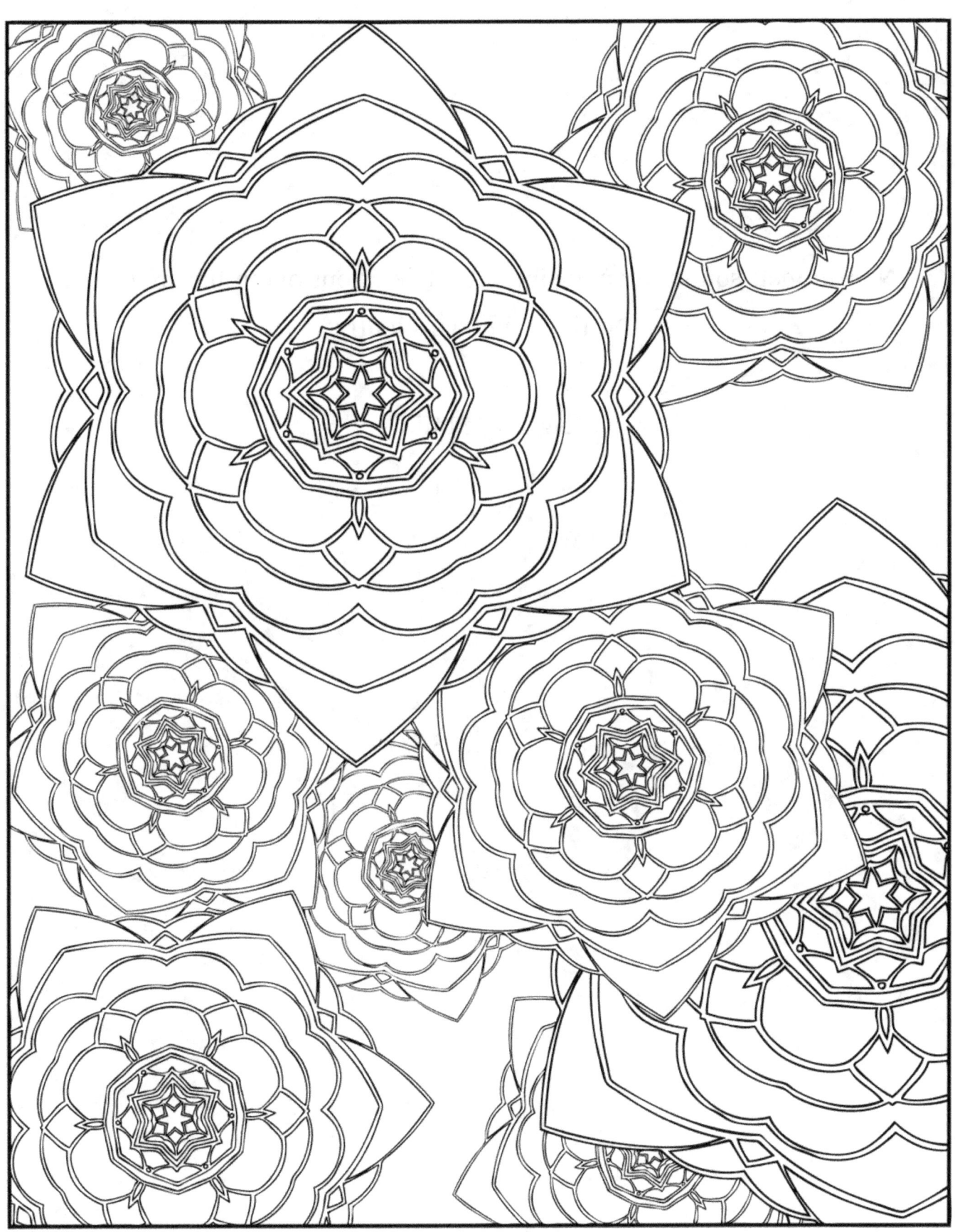

No trumpets sound when the important decisions of our life are made.

Destiny is known silently.

- Agnes de Mille -

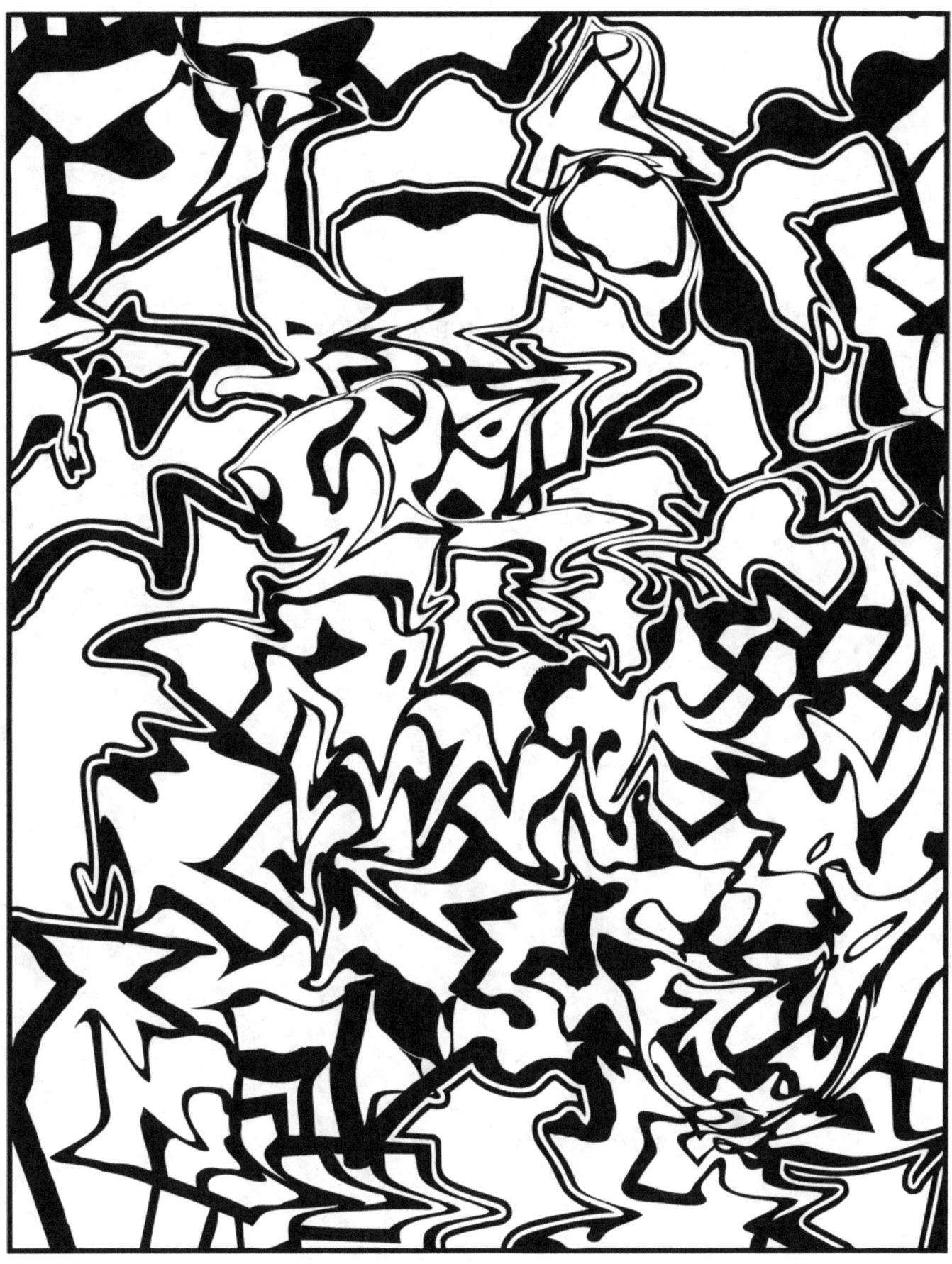

Life shrinks or expands in proportion to one's courage.

- Anais Nin –

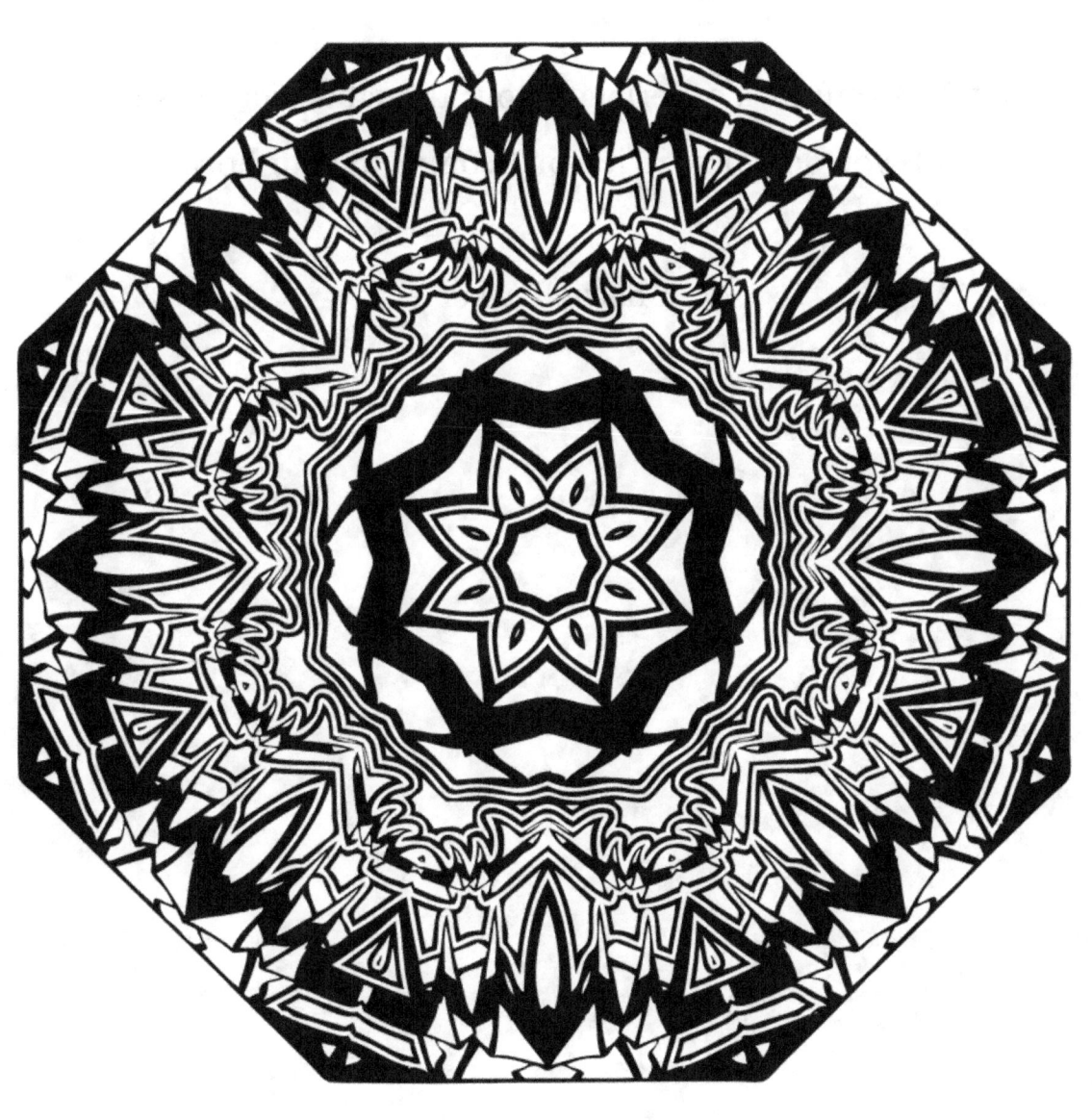

Music is your own experience, your thoughts, your wisdom.
If you don't live it, it won't come out your horn.

- Charlie Parker –

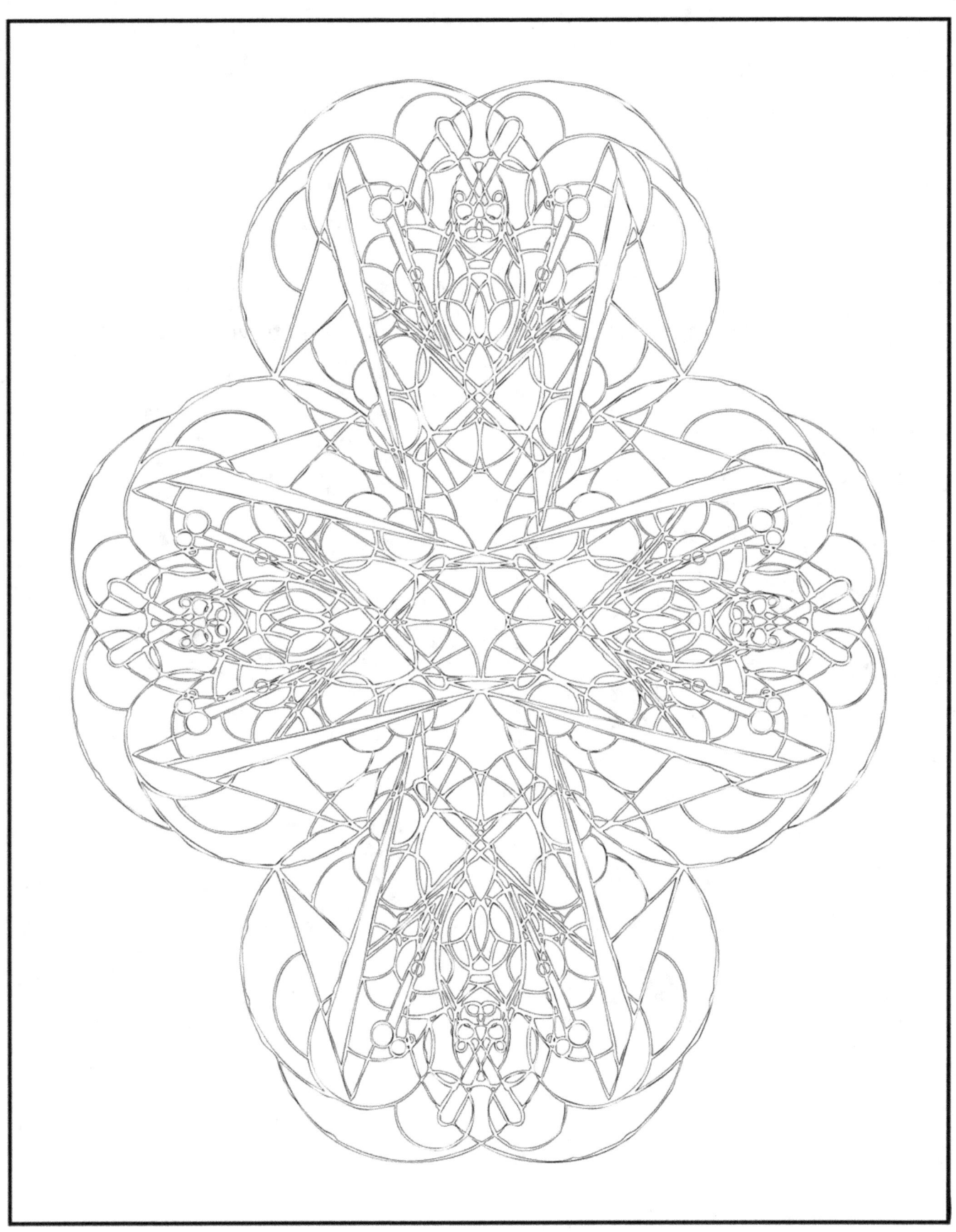

Be really whole, and all things will come to you.

- Lao-Tzu –

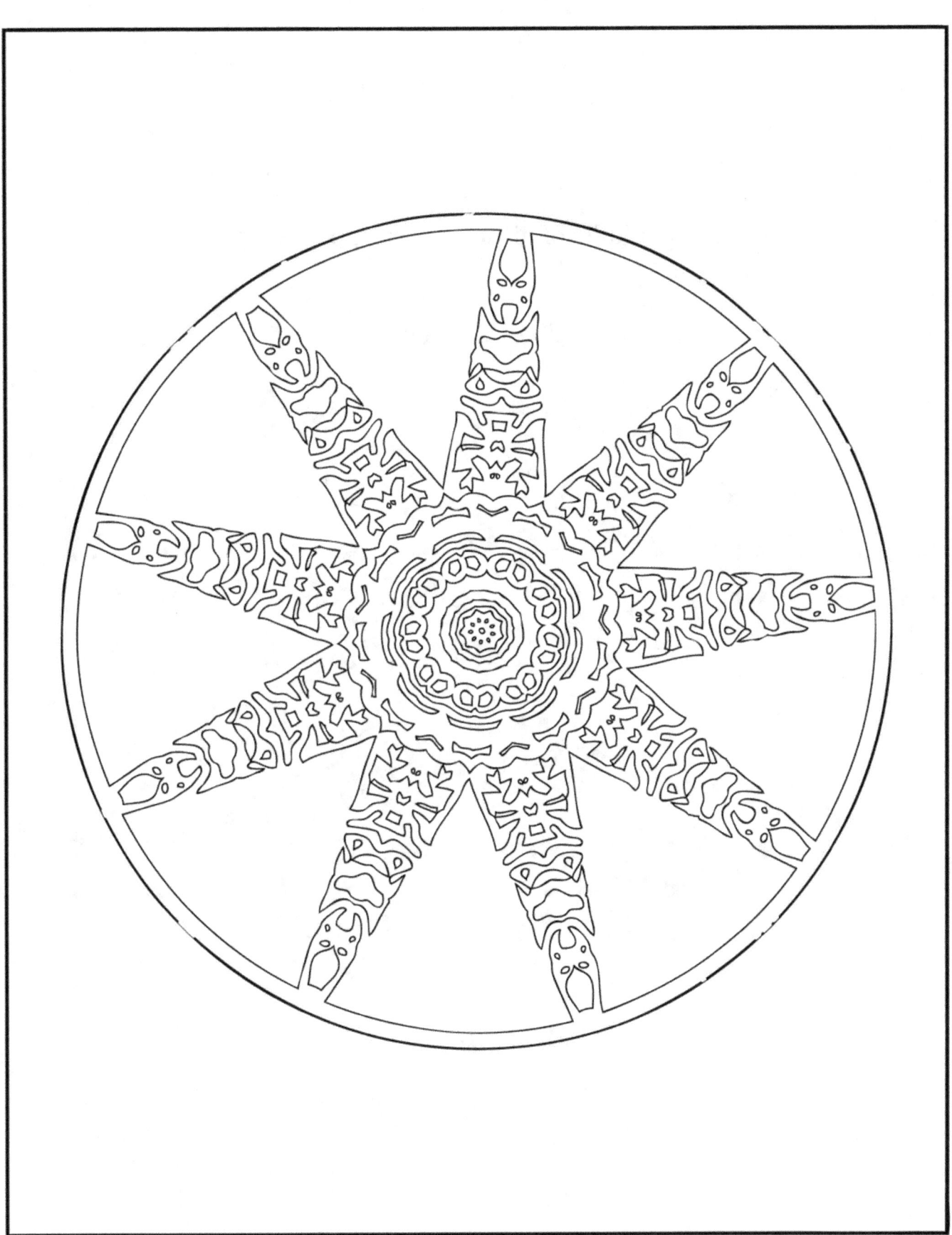

In the middle of difficulty lies opportunity.

- Albert Einstein –

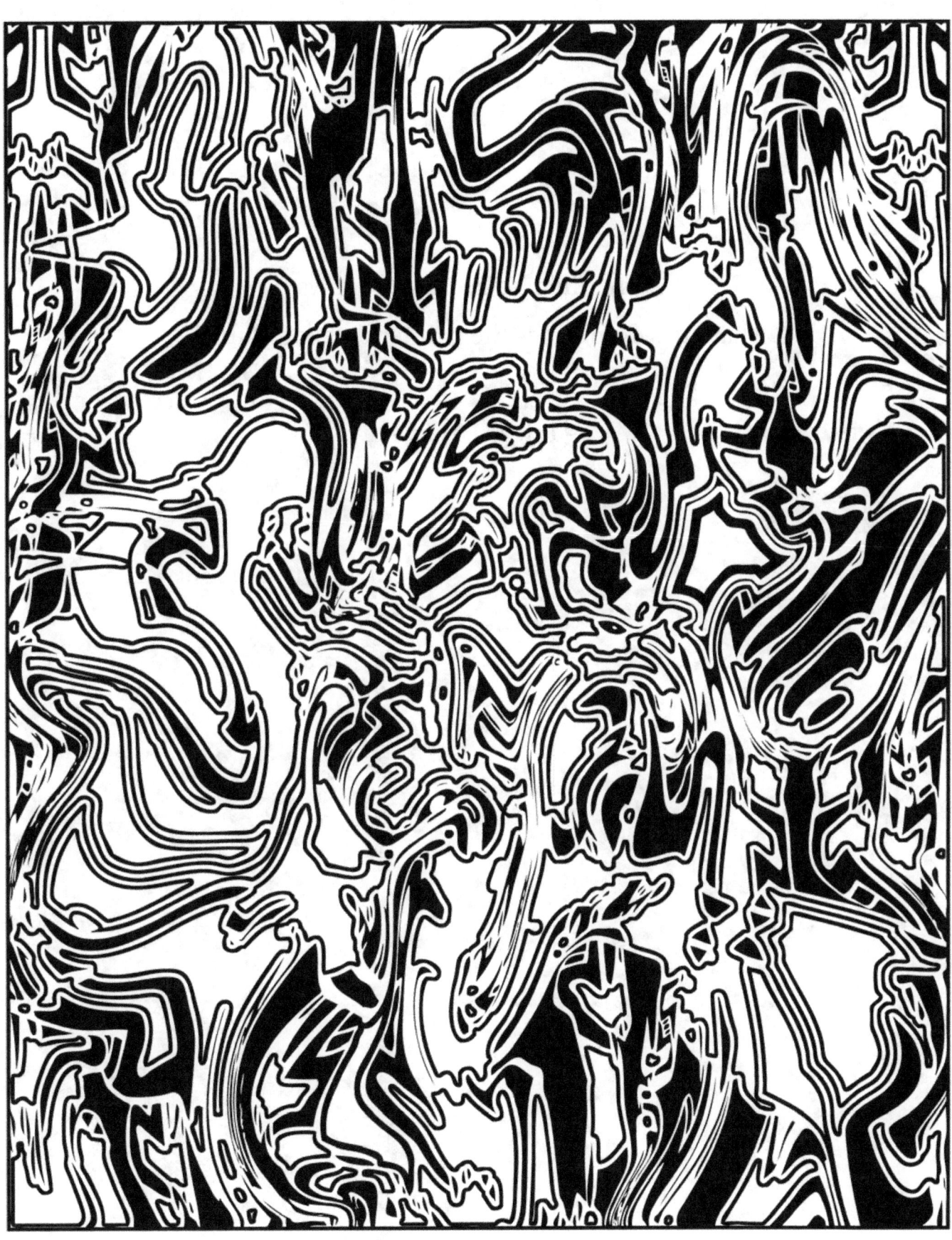

Only when he no longer knows

what he is doing does the painter do good things.

- Edgar Degas –

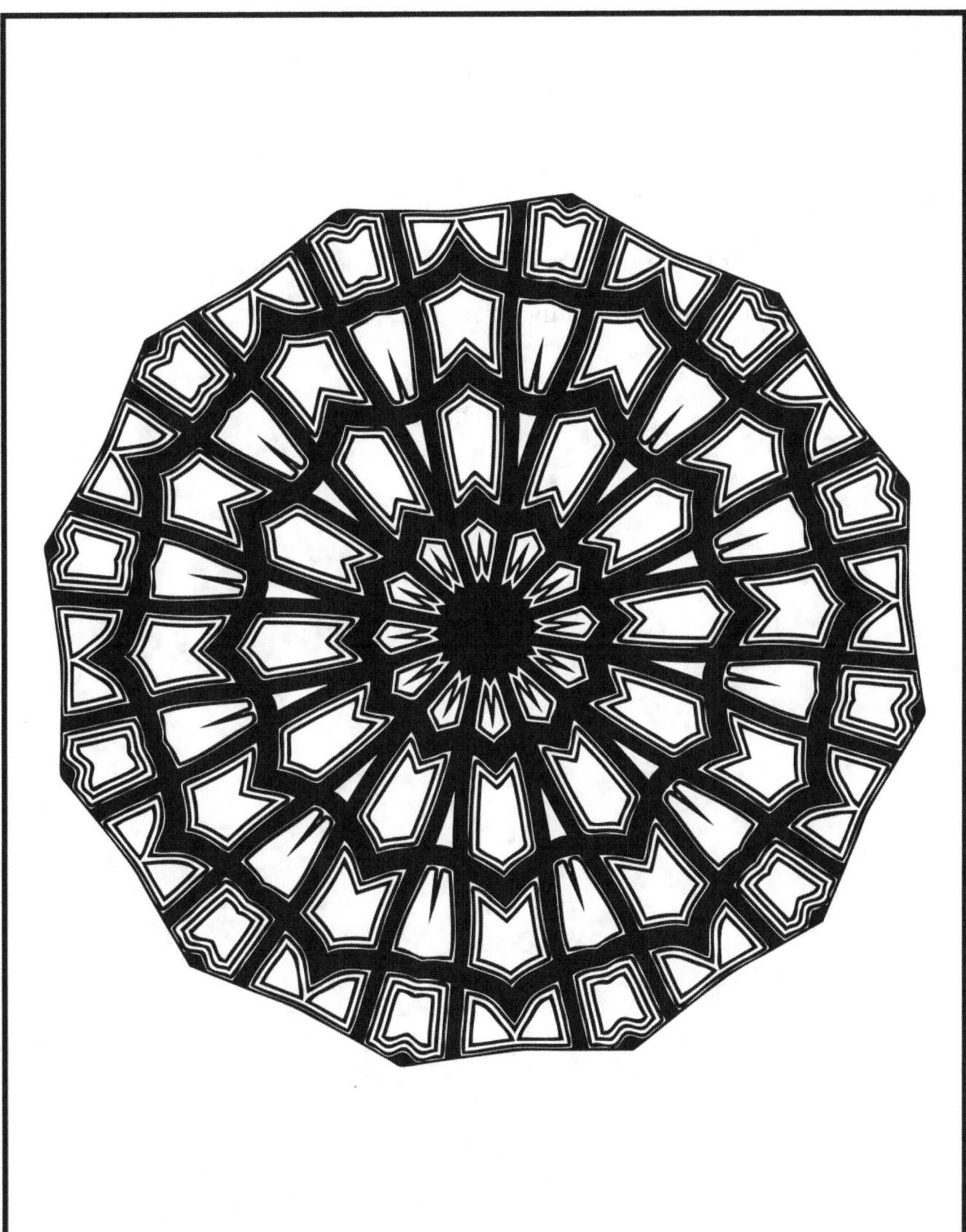

If I am not for myself, who will be for me?

And if I am only for myself, what am I?

- Hillel -

About the Artist

Ken O'Toole

Ken is an experimental artist working in various media. Much of his work involves creating a "visual vocabulary" to communicate emotional or spiritual experiences and create new perceptions.

Choosing the "classroom of doing," rather than more traditional training, has allowed O'Toole to accelerate his growth and remain open to experimentation.

His most recent works include paper sculptures. Combining action-painting and paper-folding techniques, O'Toole's paper sculptures display a myriad of surfaces resembling character sets and surreal landscapes.

His visionary, "Cultural Ghosts," series of black and white fine art photographs were the inspiration for the 2011 Sustaining Artists Juried Exhibit in Fort Worth.

Some notable exhibitions which included his work were:

- BJ Spoke Gallery, "PaperWorks" juried exhibit in New York, NY
- "Materiality" at the ARC Gallery in Chicago, IL
- Ann Metzger National Juried Exhibit in St. Louis, MO

In 2013 Ken O'Toole completed a public art project entitled, "Dreams at 100 Fathoms" which was commissioned by Fort Worth Public Arts for the Marine Park Family Aquatic Center.

Website: https://otoolestudio.com

Email: ken@otoolestudio.com

www.ingramcontent.com/pod-product-compliance
Lightning Source LLC
Chambersburg PA
CBHW060010210526
45170CB00017B/2130